COLOR
HARMONY
LAYOUT

More than 800 Colorways for Layouts That Work

COLOR
HARMONY
LAYOUT

GLOUCESTER MASSACHUSETTS

ROCKPORT
PUBLISHERS

tmarks

© 2006 by Rockport Publishers, Inc.

All rights reserved. No part of this book may be reproduced in any form without written permission of the copyright owners. All images in this book have been reproduced with the knowledge and prior consent of the artists concerned, and no responsibility is accepted by producer, publisher, or printer for any infringement of copyright or otherwise, arising from the contents of this publication. Every effort has been made to ensure that credits accurately comply with information supplied. We apologize for any inaccuracies that may have occurred and will resolve inaccurate or missing information in a subsequent reprinting of the book.

The color swatches contained in this book are as accurate as possible. However, due to the nature of the four-color printing process, slight variations can occur due to the ink balancing on press. Every effort has been made to minimize these variations.

First published in the United States of America by
Rockport Publishers, a member of
Quayside Publishing Group
33 Commercial Street
Gloucester, Massachusetts 01930-5089
Telephone: (978) 282-9590
Fax: (978) 283-2742
www.rockpub.com

ISBN-13: 978-1-59253-258-2
ISBN-10: 1-59253-258-6

10 9 8 7 6 5 4 3 2 1

Design: tmarks
Layout and Production: tmarks

Printed in Singapore

To the people who believe deeply, especially AJ and Julie

contents

8 Introduction

11 Color Case Studies
12 DICASA
13 SHOWBOX
14 *GESCHÄFTSBERICHTE: FINEST FACTS & FIGURES*
15 WALK THE LINE
16 AICHI EXPO 2005
17 AMERICAN PLAYERS THEATRE
18 GENZ-RYAN
19 ROOTS
20 MRS. MEYER'S CLEAN DAY
21 MAMMA GUN

22 Selecting Color

24 Color That Speaks
- 26 POWERFUL
- 36 RICH
- 46 ROMANTIC
- 56 EARTHY
- 66 FRIENDLY
- 76 SOFT
- 86 WELCOMING
- 96 ELEGANT
- 106 TRENDY
- 116 FRESH
- 126 TRADITIONAL
- 136 REFRESHING
- 146 TROPICAL
- 156 CLASSIC
- 166 CALM
- 176 REGAL
- 186 ENERGETIC
- 196 SUBDUED
- 206 PROFESSIONAL
- 216 PURE
- 226 GRAPHIC

236 Process Color Formulas

256 Directory of Contributors

introduction

Graphic design is a jealous mistress. She wants all your time; your days as well as the wee hours, with only a weekend off here and there for good behavior.

More than that, design wants you to reinvent yourself at every turn. Design asks you to be nearly all things to all people—or perhaps allows you to be many things to many people. This freedom is one of the great joys of being a designer. Certainly you'd have every right to complain if all you ever got to be was an organized, efficient designer of black-and-white forms—but that is rare.

As designers, we must be able to be everything from cool and calm to energetic and powerful. One of the most powerful ways to communicate this range is through color. We are in the business of creating perception for our clients—and perception, if it doesn't start with color in the first place, is often solidified with it. Would Starbucks be the same without its ubiquitous green? Would Microsoft's Windows logo be as meaningful without its range of color? Maybe, but the meaning would be different—and therein lies the point.

In just a glance, color defines things in a viewer's mind before they have a chance to interpret words or images. It can even change the meaning of an image or word entirely. Think of the word "blood" printed in deep red; print it in bright yellow and the message changes. Though as designers we often gravitate to our stable of styles and typefaces, each of us has access to the full breadth of color—and most of us use it with abandon, if not reckless abandon. It's important to remember that color is a powerful tool that when harnessed and truly understood, can make or break a design. Even little tricks like a hidden complementary color can make an element stand out as important or fade as a tint.

Better use of color makes a design more effective; meanings gain clarity and deepen. We all have associations with colors yet sometimes don't know why. For example, green is money. Green is envy. Green is "go." Green is nature. As designers, we need to understand what specific colors convey and use them to help communicate our intended message to the target audiences.

After one learns the properties and personalities of colors by themselves, the next step is learning how to use them in concert, which is what we will explore in this book. We will examine a number of layouts with successful palettes, then explore different color schemes and how they affect both appearance and meaning. This book is an omnibus of color effect; each chapter will give you a broad range of successful palette choices for conveying different messages. With your color quiver now fully stocked, you just need to add your own creativity to create dynamic and communicative work.

color case studies

This is a different kind of book on color: not scientific, but not wholly romantic. It is a working book to help designers clarify—or challenge—their thoughts on color as they relate to the practice of design.

We begin by profiling ten outstanding recent works of design from all over the world that show how color choices contribute to a design's success. The ensuing chapters examine each of these projects but group them in ranges of color that delineate a variety of adjectives. Each adjective is supported by a color palette that helps define the word visually. In many cases, color contributes new life to the words and causes them to evoke new meanings.

The palettes in this book can be a departure point for your own design, a tool to jump-start your thinking, provide insight on color relationships, and help you say just what you need to say. Color speaks, and this book will help you speak more effectively.

DiCasa

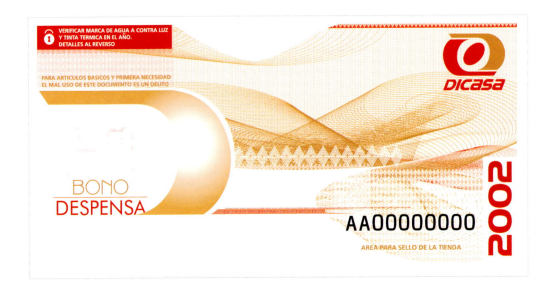

This project presented an interesting design opportunity. The Mexican government asked Origin Design of Houston to create a series of scrips that would function in place of peso-denominated paper money. The scrips function much like coupons, allowing bearers to secure food, clothing, or gas, depending on specific designation.

The design problem was to create a currency system that would work in its own world, replete with a visual language. Each of the different scrips has its own color scheme, enabling easy identification of the various denominations. Although, like most currency, it uses text identifiers for formal designation, the color scheme is the element that most readily identifies the denomination.

Though use of color in this manner is by no means a watershed idea, the scrips' delicate and intricate design, which incorporates seven different security features and numerous color variations, makes them incredible pieces of work. Simply put, they are beautiful.

DiCasa
Currency for government-assisted support of impoverished citizens of Mexico.

design firm:
Origin Design

creative director:
Jim Mousner

designer:
Jennifer Gabiola

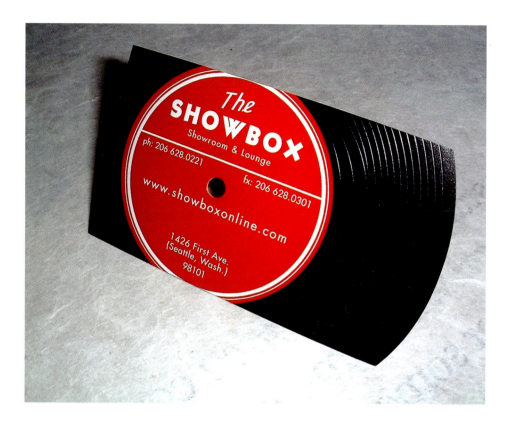

SHOWBOX
business card

design firm:
tmarks

designer:
Terry Marks

The Showbox is among the crown jewels of hipsterdom in Seattle. Since 1939, acts as varied as Cab Calloway, The Village People, and Bright Eyes have graced the stage. It is *the* place to see great music before it becomes the property of the masses.

Though none of this project's design choices is remarkable on its own, the sum just works—period. Given the lack of an official logo, the possibilities were endless. The memorable final product bespeaks the essence of the Showbox. That is to say, it speaks of music.

Thanks to DJs, the LP, and the 45 ("7-inch" to hipsters) are still recognizable. The design is a sleek take on this retro form, down to the debossed, clear-foiled grooves and drilled center hole. But it's the graphic, striking color scheme that grabs you. To let the viewer know you mean business, nothing beats black and red.

Geschäftsberichte: FFF — Finest Facts & Figures

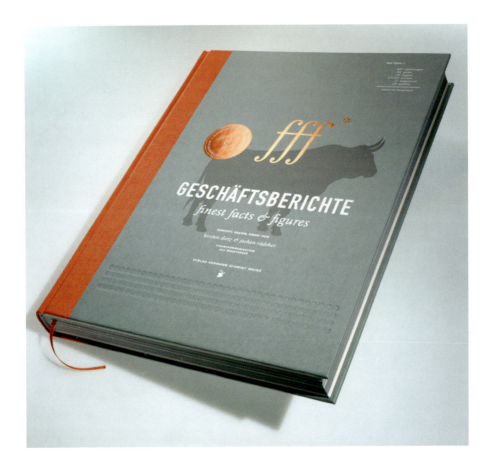

From German design firm strichpunkt comes *Geschäftsberichte: finest facts & figures*, a guide to developing and designing annual reports. (*Geschaftsberichte* is the German word for "annual report.")

Annual reports are always a rich arena for graphic design. In this example, the cover composition delivers a layered, textured, elegant, yet playful solution. The bull, which we assume to be a symbol for a bull market, is perhaps traditional. The *fff*, representing the name *finest facts & figures*, is nontraditional. Yet it makes for a wonderful ligature.

The color—muted green with a hint of blue—is set off with orange, which implies boldness and a modern visual aesthetic. For the rest of the type, however, the designers chose silver, refining the subject matter while simultaneously grounding it with its modern sensibilities.

Geschäftsberichte: finest facts & figures
Book detailing the craft of superior annual reports

agency:
strichpunkt

creative direction:
Kirsten Dietz
Jochen Rädeker

designers:
Kirsten Dietz, Susanne Hörner, Holger Jungkunz, Jochen Rädeker, Felix Widmaier

illustration:
Felix Widmaier

Walk the Line

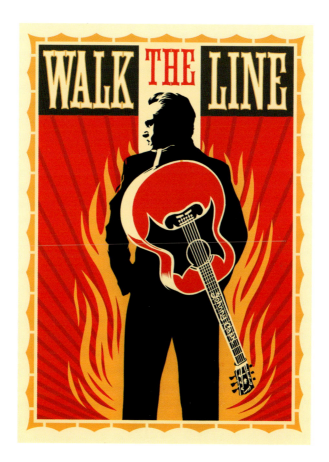

Walk the Line
A movie poster for *Walk the Line*, a major motion picture about the life of Johnny Cash

agency:
Studio Number One

credits:
Shepard Fairey

Seemingly everyone loves Johnny Cash, America's favorite bad boy who was once referred to as the embodiment of "red, white, and black." Through his long and varied career, Cash's work retained the same force and verve of his early landmark work. A film about his life wouldn't be right if it didn't pay homage to those early days.

Shepard Fairey's poster for *Walk the Line* harkens back to a letterpress or screenprinting style popularized by music posters in the early- to mid-twentieth century. The colors themselves are meant to be noticed. The red, the yellow—in fact, the entire composition—is anchored in the center with probably the only thing it could be centered with: the Man in Black himself (or, at least, as played by Joaquin Phoenix). The colors, not quite primary, imply hard-won wisdom, a reality in which things are not so bright and easy but where passion and conviction are what matter.

The poster is great in large part because it is not what most movie posters are: slick photomontage creations. It is drawing, lettering, and color—the basics, the roots, and the core elements.

Aichi Expo 2005

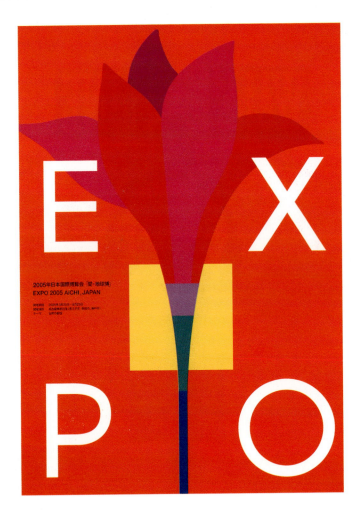

This wonderful work created for the World Exposition held in Aichi Prefecture (on Japan's main island, Honshu) takes its inspiration from the Expo's overarching theme, nature's wisdom. The expo provides a forum for sharing ideas and working together on a global scale while promoting the goal of binding humanity to nature. Keeping to this theme, the designer chose a flower, which symbolizes growth and the wisdom nature holds, and used a color palette representing the people and countries of the global community.

Known for using highly stylized flowers in his work, Kojima uses the strength of these adaptations from nature as the focal point. He further emphasizes this stylization by using flat expanses of naturally derived color. That being said, the piece works for another reason—its simple beauty.

Expo 2005
poster

designer:
Ryohei Kojima

American Players Theatre

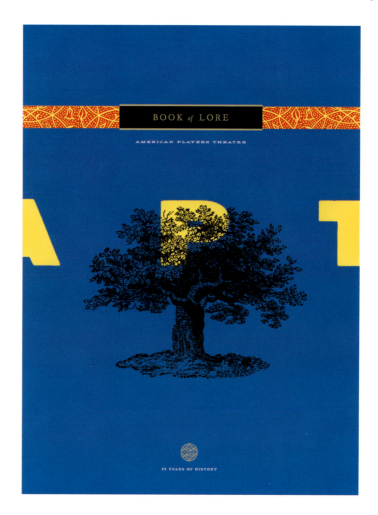

American Players Theatre
Book of Lore
Season brochures

design firm:
Planet Propaganda

creative director:
Dana Lytle

designer:
Geoff Haber

writer:
John Anderson

Planet Propaganda used color powerfully when working with the American Players Theatre on the *Book of Lore*, which celebrates the organization's twenty-fifth anniversary. It moves the piece from page to page and section to section as the story moves through the theatre's history. Each section or show recounted in the book is defined largely by color, resulting in a lively and intimate document that portrays and conveys meaning much more clearly than mere type on paper ever could.

The cover's quiet strength and somber beauty are impossible to ignore and provide an apt accompaniment to the thoughtful interiors. Executed in the same style of solid colors played against one another—purple connoting regality, yellow shining brightly, and the orange patterns and gold title grounded with rich black—the result is a sophisticated composition that conveys elegance and depth of content.

Genz-Ryan

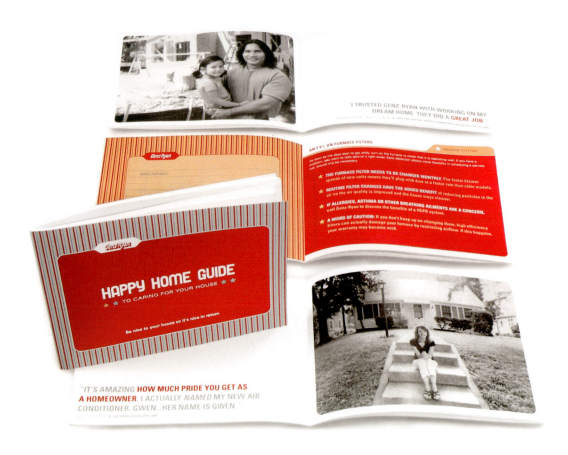

This unique piece was designed to help people with the care of their home. For a heating and plumbing company—an industry not particularly known for its attention to customer service—Catalyst Studios did a remarkable job producing a how-to guide for homeowners. In particular, they covey the lengths to which their client will go in pursuit of customer satisfaction.

Demystifying the sometimes unfamiliar and opaque realm of home-building through essential maintenance information, upkeep schedules, and helpful checklists, the document welcomes homeowners to their new space and celebrates the event though strong color and a modern sensibility—a friendlier and more approachable format than the pieces that dominate this market, which traditionally have an industrial feel. In fact, the end product arguably resembles a candy box more than a homeowner's guide. Bright red is supported by baby blue, peach, and a pale olive. The colors are inviting and fresh, helping to complete a design aimed at making the reader not only interested but also welcome.

Genz-Ryan
Happy Home Guide

art directors:
Beth Mueller, Jason Tysavy
designers:
Jodi Eckes, Maria Besonen
illustrators:
Jodi Eckes, Maria Besonen
copywriter:
Eric Luoma
photographer:
Jeff Johnson Photography
printer:
Print Craft, Inc.

Roots

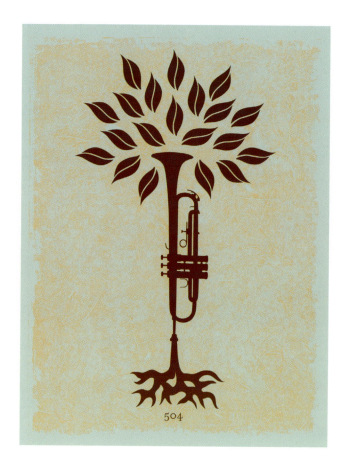

Roots
Fund-raising poster for
Hurricane Katrina relief

designer:
Josh Higgins

Designed by the multitalented Josh Higgins of San Diego, Roots is a submission for the Hurricane Poster Project. The project solicited submissions from artists and designers to be sold online to generate funds to assist the Red Cross in caring for the victims of Hurricane Katrina.

Higgins, a well-known musician in his own right and jazz aficionado, displays his love of music in this piece. The trumpet, a symbol for New Orleans jazz, sprouts new roots and flourishes again in the wake of tragedy. Higgins pays further tribute to New Orleans by making its area code, 504, the sole typographical element.

The color palette makes the trumpet the most salient element. The green background and texture field provide a rich, fertile place from which to spring. So often, pieces of design created for one's self or for a cause become showpieces—unfortunately, showpieces for one's own ego. Higgins' pieces, however, have the opposite goal: to be grounded, to be accessible, to be—for the lack of a better term—real.

Higgins might have drawn on any of a number of color solutions, all of them attractive or "cool." He chose to honor the intent of the project and, in so doing, honored those who endured, or tragically, perished in, the hurricane.

Mrs. Meyer's Clean Day Products

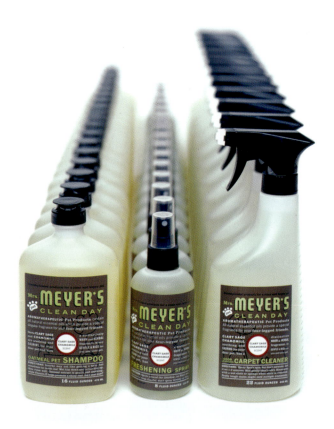

In some situations, the package could well make the product—and this is one of those situations. Though Werner Design Werks created a design that is strong and nostalgic, with a tinge of the new, it's the color scheme that elevates it to something greater than your average pet product.

This offering is an extension of a cleaning product line that promises a no-frills, aromatherapeutic way to keep your pet, happy, clean, and smelling great. The Pet Products line works better than could be expected, given the market leap this line of products represents.

This piece is perhaps the best example in this book of how powerful color can be. Here, it is the color that makes differentiation from the main line of products possible in the first place. While the type defines the step away, it is the color that connotes it.

For everything to work, the colors have to be in concert. The deep gray-brown confers sophistication and strength; the red brings life and verve. Together with the great type choices and strongly conceived layout, the color makes for a wonderful solution that undoubtedly merits all the shelf space it garners.

Mrs. Meyer's Clean Day
Packaging for aromatherapeutic cleaning products for pet owners

designers:
Sharon Werner and Sarah Nelson

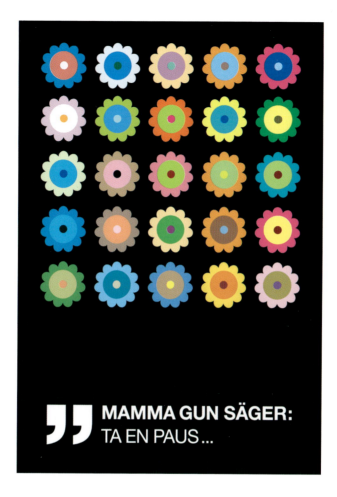

Mamma Gun
Graphics for Swedish café in Japan

designer:
Next Century Modern

Mamma Gun was a café created for an event, Swedish Style Tokyo, which celebrated and displayed design, food, art, and music. Mamma Gun is also the name of a person—designer Jessper Larsson's mother, Gun Larsson, who used to run a café in Sweden.

The flower graphic is beautiful, simple, and adapts easily and powerfully to multiple color palettes. It's iconic. The tagline "Mamma Gun sager: Ta en paus"—which translates to "Mother Gun says: Take a break"—echoes a laid-back, self-aware confidence.

The layout is adaptable and universal. Whether presented as a single form on the T-shirt or set on a field of black on the event poster, it works in a variety of color palettes. Such versatility means that this piece can be all things to all people, if they would just "take a break."

For such delicate subject matter, the design itself is almost brusque. The pinks, however, pull the piece into a realm of softness, especially when played off the soft blue. The faint olive contrasts the pink with a near-complementary color for visual interest, for color play, and also grounds the piece in a more sophisticated and interesting manner than if the piece had included only the pink and blue.

selecting color

Color selection is an essential step in the design process, as color is one of the first elements communicated by a design. Without careful forethought and early planning, a designer's color choices can veer down the wrong path, which can ultimately lead to inappropriate or weak design decisions. A strong first step is to forget any preconceived notions you may have and ask yourself critical questions about the needs of the piece.

Color palettes are often dictated by current trends, either consciously or subconsciously. Trends become self-propagating: the more we see a color being used, the more we use it. As a result, eras of design can often be identified by this element alone. Color selection, however, should be guided by the purpose of the piece and enhance its ability to communicate a message to the target audience, rather than reflect what is currently in style.

Beauty—or rather, one's personal notions of beauty—can also be a natural reflex when choosing a palette. This impulse is extremely subjective; colloquial representations, standards of beauty, or personal preferences might not relate to—or might even distract from—your client's design needs. If this is the case and beauty is the chosen design strategy, the end result may be wonderful to look at but unable to clearly communicate to its audience.

To avoid these common mistakes, it is essential to determine the goals of the work with the client before setting down to develop the design. This step will ensure that the emphasis remains on the message rather than the means. While we often feel we know what the proper solution is for a particular project, it can be enlightening if not inspiring, to realize that the unexpected is the most appropriate route. Conversations with the client often result in happenstance information that critically informs the final solution. Begin by asking your client the following questions:

- What is the goal of the piece?
- Who is the audience?
- What should the audience take away from this?

Color can soothe, excite, or create a negative reaction—it all depends upon what mood you need to set or what message you need to communicate. Once you have answered the core questions above, it is important to then define what kind of emotional message your piece should convey. It is essential to define this early with your client, or propose something to your client if they are unsure of the answer.

If not restricted by seasonal concerns, approved brand colors, or what the CEO's wife prefers, color can be used to great advantage, and as such should be well thought through. Color can grab attention, reflect a place or feeling, or lend approachability and credibility. It is but one of the elements that makes a design work or not, but it is one of the most powerful, so choose wisely.

color that speaks

In design, it is the ability to speak, to tell a story, that ensures the success of a piece. Color can communicate broad strokes or it can relate a depth of meaning beyond a composition or set of words. Knowing the nuances—and which colors move with others—gives us a forum from which to give voice to the stories we want to tell.

Beneath each piece of art featured in this section are numbers that refer to the Process Color Formulas, beginning on page 236. Each number listed corresponds to a color used in the featured design. The colors provided in this appendix include CMYK color conversions so you can replicate any color combination—and create original combinations—for your own designs.

powerful

Powerful colors not only demand your attention, they reward it. From bright happiness to heated passion, the emotions these colors evoke are about getting noticed and being known. They are the unflagging vitality and self-knowledge of youth. Red—a color that can neither be denied nor ignored—is iconic in this role and the backbone of this group.

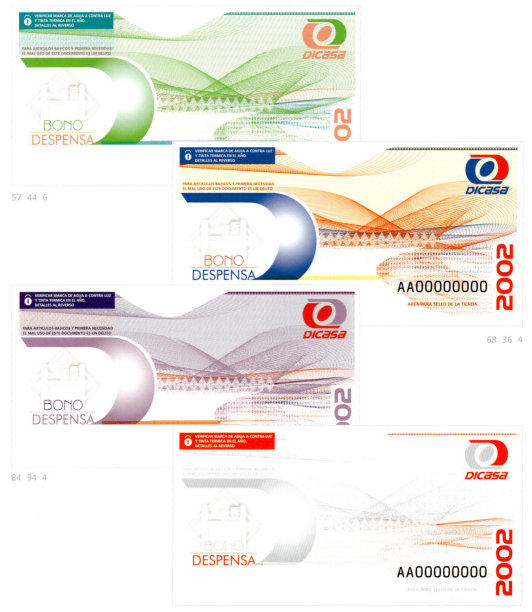

57 44 6

68 36 4

84 94 4

97 100 4

26 Color Harmony: Layout See Process Color Formulas on page 236 for CMYK values of colors shown

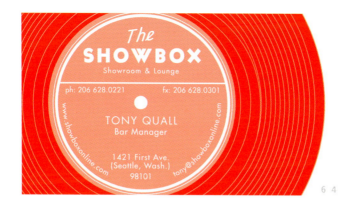
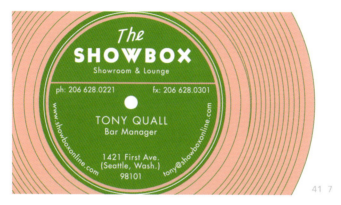
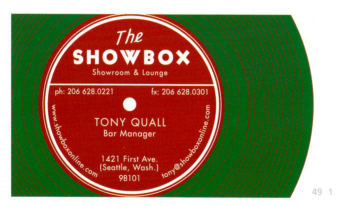
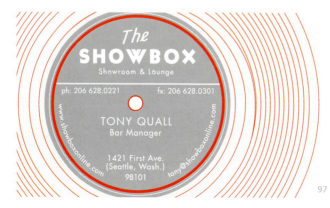

powerful

powerful

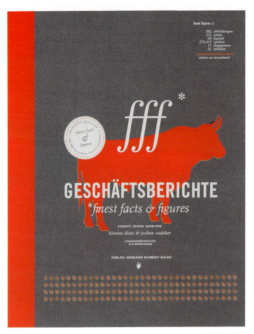
4 98 104

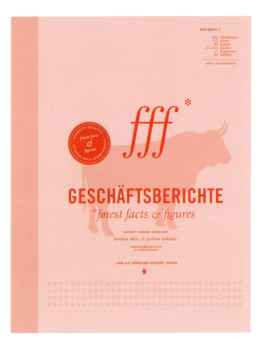
4 7 6

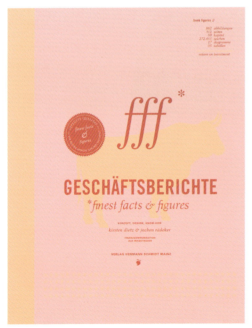
7 22 11

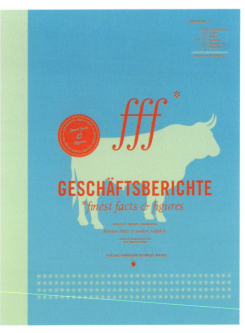
4 46 61

28 Color Harmony: Layout

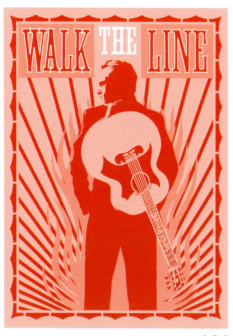
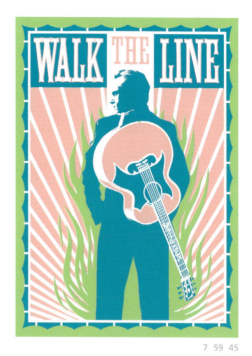

powerful

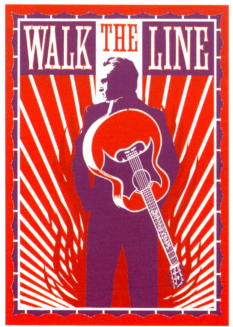
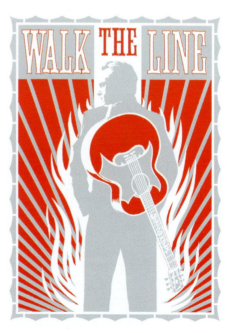

powerful

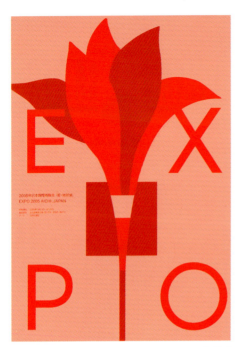
6 2 4

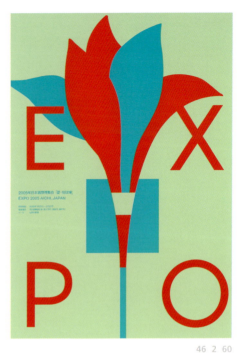
46 2 60

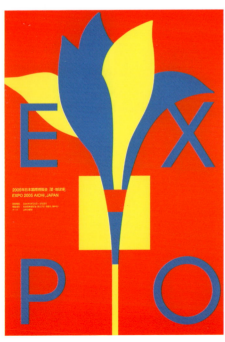
68 36 4

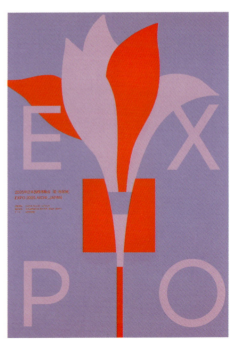
86 94 3

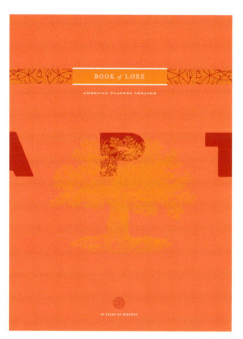

3 13 20

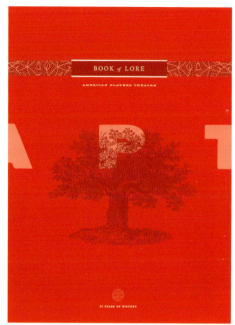

6 2 4

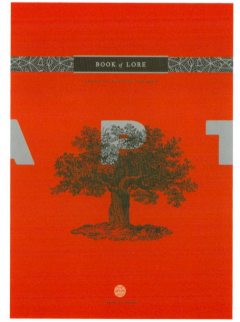

101 4 105

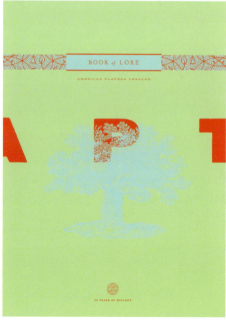

4 46 63

powerful

powerful

2 7 4

41 4 62

94 2 14

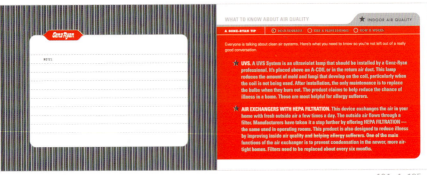

101 4 105

32 Color Harmony: Layout

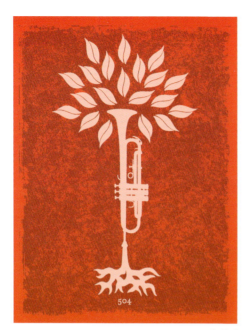

2 7 4

43 1

47 4 63

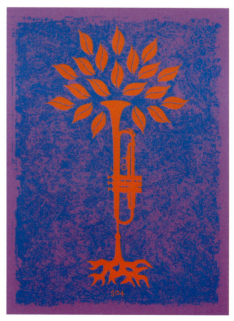

84 92 4

powerful

powerful

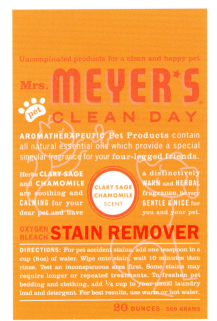

4 12 20

5 44 61

70 38 6

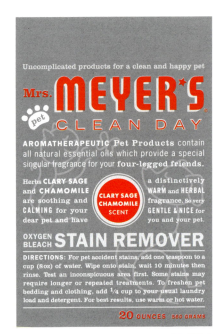

97 102 4

34 Color Harmony: Layout

 MAMMA GUN SÄGER: TA EN PAUS...

4 98 104

 MAMMA GUN SÄGER: TA EN PAUS...

63 42 6

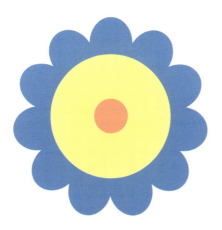

 MAMMA GUN SÄGER: TA EN PAUS...

70 38 6

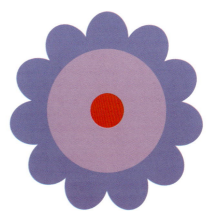

 MAMMA GUN SÄGER: TA EN PAUS...

86 94 3

powerful

rich

Confident and dark, hues that conjure richness are a step toward black. Deep tones that convey understated strength can also convey affluence. They speak of wealth and the strength of mind, of the patience, wisdom, and confidence one must have to allow events and circumstances to unfold in their own manner.

Dark reds reminiscent of fine wine and greens of the deep forest contribute to this rich palette that demands examination, a look at what lies beyond the surface.

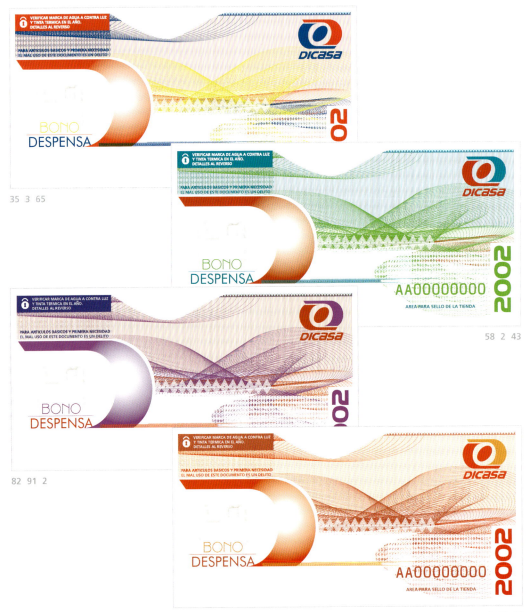

35 3 65

58 2 43

82 91 2

3 10 19

Color Harmony: Layout See Process Color Formulas on page 236 for CMYK values of colors shown

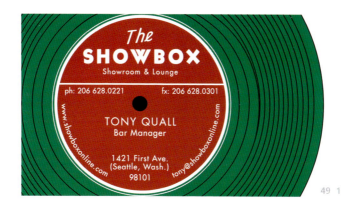
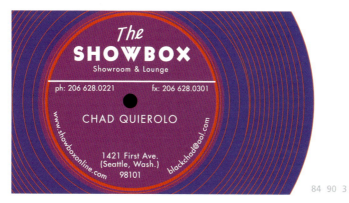
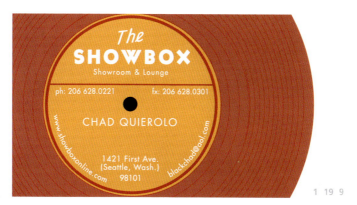
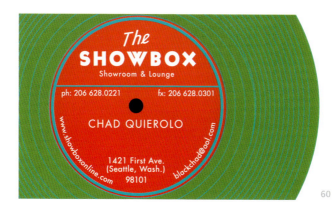

rich

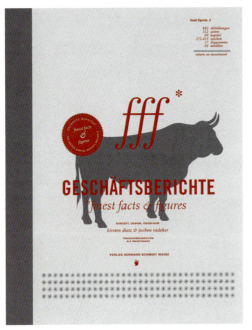

1 98 104

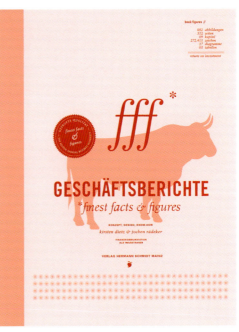

6 8 2

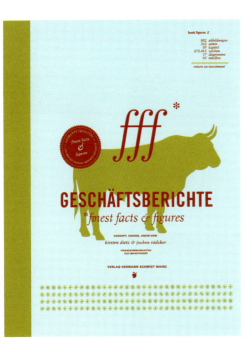

33 1 64

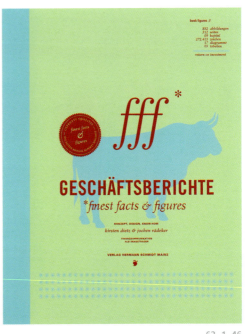

62 1 46

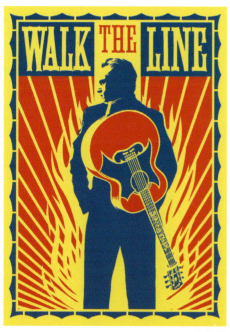
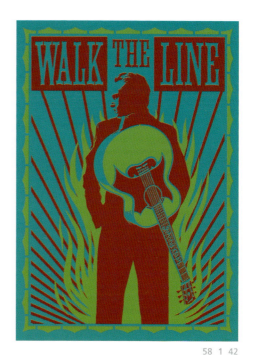

rich

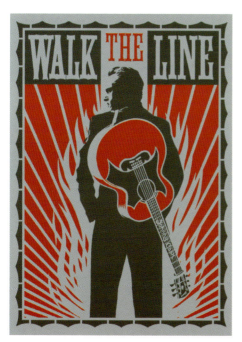
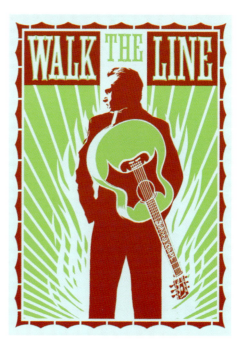

35 3 65

58 1 42

101 2 105

64 1 45

rich

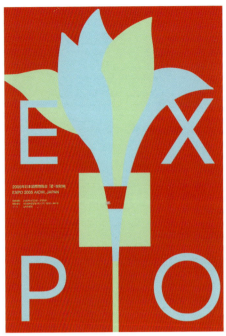
2 46 63

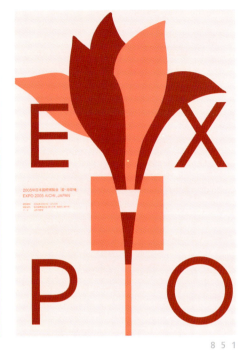
8 5 1

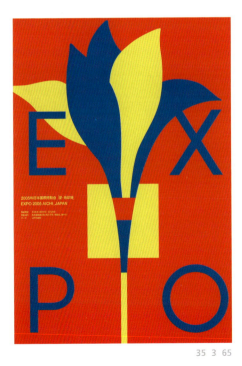
35 3 65

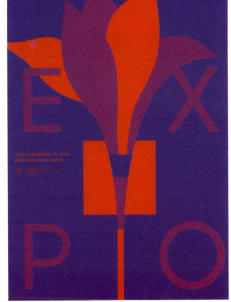
84 90 3

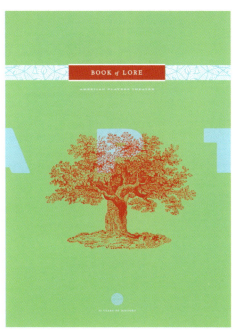

63 3 45

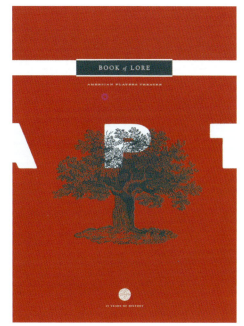

rich

97 2 105

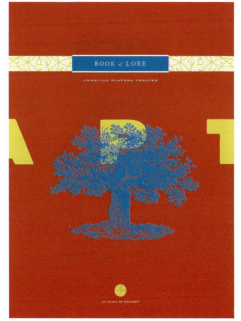

34 2 66

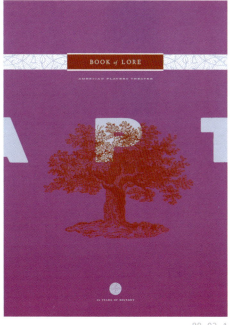

88 92 1

rich

42 Color Harmony: Layout

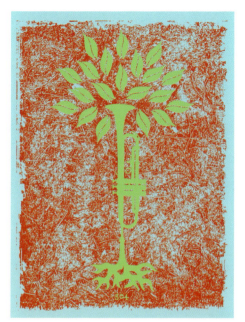

63 3 45

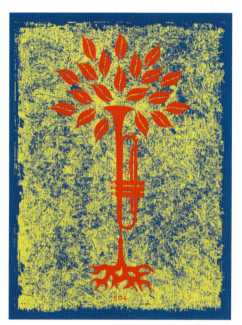

35 3 65

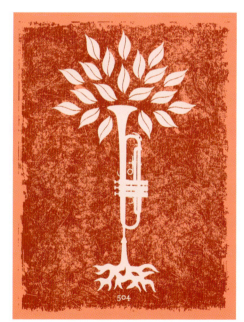

6 8 2

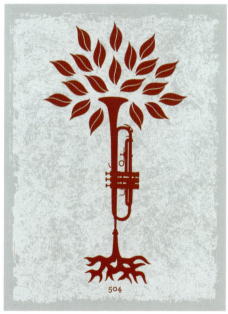

98 100 1

rich

rich

6 8 2

33 1 64

88 92 1

3 45 62

44 Color Harmony: Layout

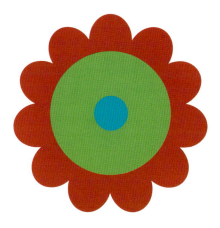

„ **MAMMA GUN SÄGER:**
TA EN PAUS...

1 42 59

„ **MAMMA GUN SÄGER:**
TA EN PAUS...

3 5 2

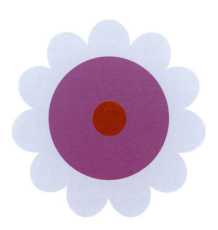

„ MAMMA GUN SÄGER:
TA EN PAUS...

88 92 1

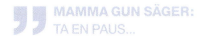

„ MAMMA GUN SÄGER:
TA EN PAUS...

101 2 105

rich

romantic

We all want it, whether we're willing to admit it or not. From the brashest of bachelors to the women who decry the very existence of the color pink, we all wish for romance. The secret song of the heart is to know and to be known. Nary a soul will deny that pinks and reds say this better than any other colors.

Indeed, pinks and reds, as well as peach, lavender, gentle yellows, and the greens of flower stems are the most obvious colors of romance. The softer, pastel tones of blues and even grays figure into the palette as well.

8 12 23

47 6 60

47 64 7

87 96 8

Color Harmony: Layout See Process Color Formulas on page 236 for CMYK values of colors shown

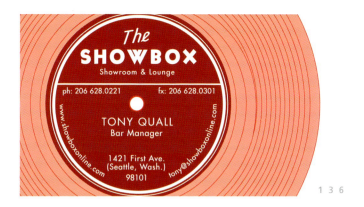

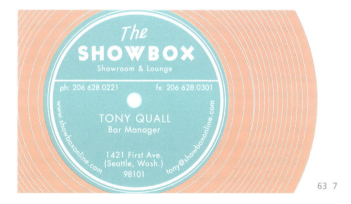

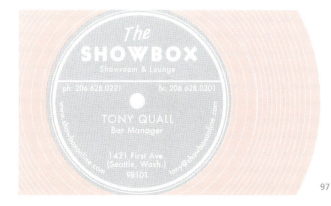

romantic

romantic

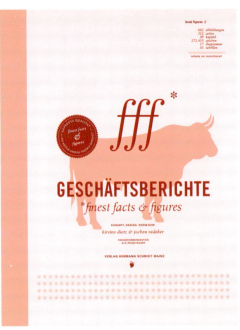

1 8 6

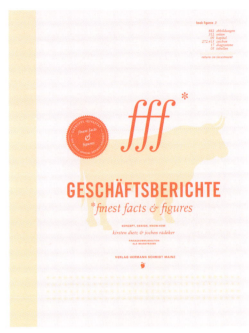

8 12 23

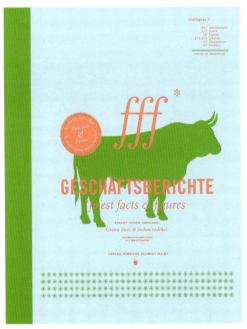

43 64 5

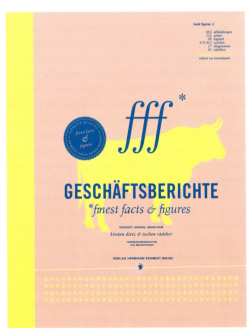

67 37 7

48 Color Harmony: Layout

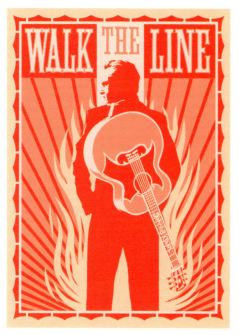

5 16 23

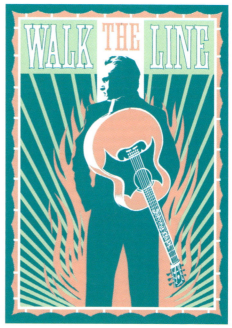

47 7 59

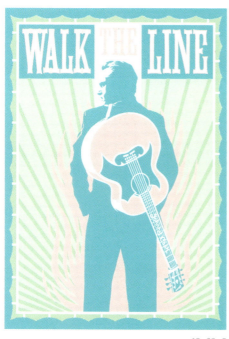

48 62 8

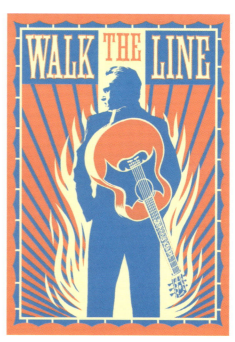

70 39 6

romantic

romantic

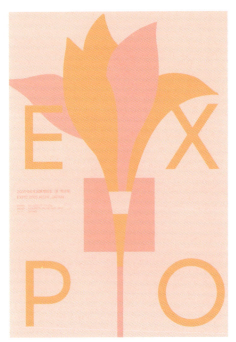

7 16 22

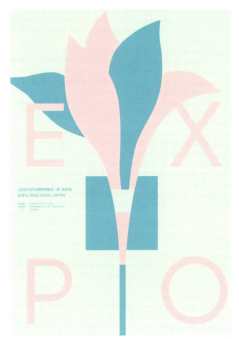

48 62 8

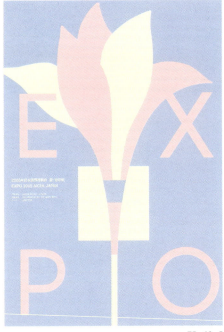

72 40 8

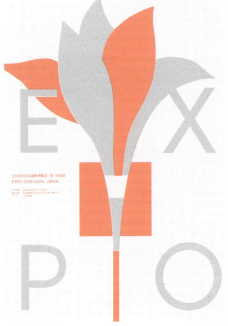

99 97 6

Color Harmony: Layout

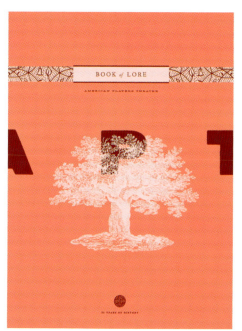

8 1 6

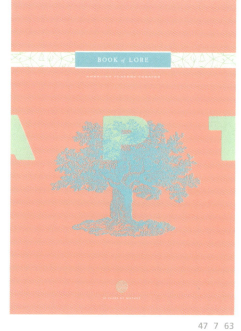

47 7 63

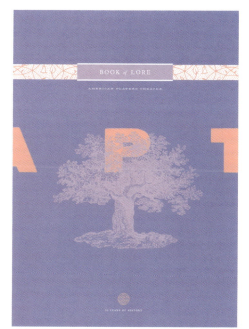

87 95 7

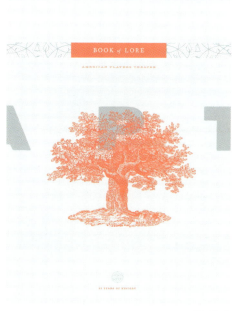

99 97 6

romantic

romantic

43 6 57

72 40 8

95 7 14

99 97 6

Color Harmony: Layout

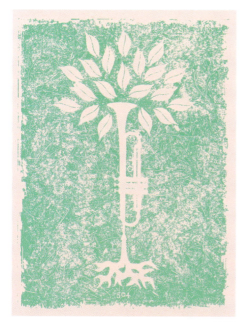

8 54

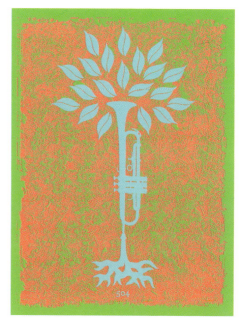

45 6 63

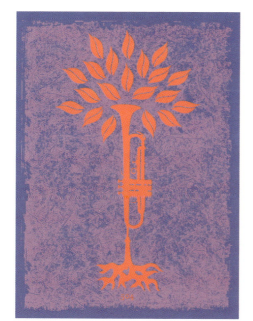

86 94 6

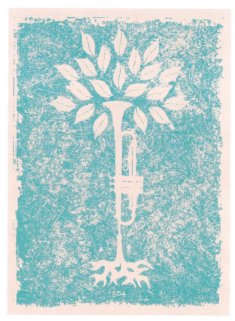

61 8

romantic

romantic

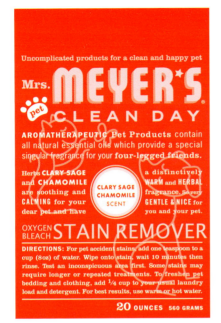

4 8 6

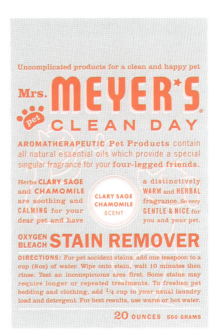

5 8 98

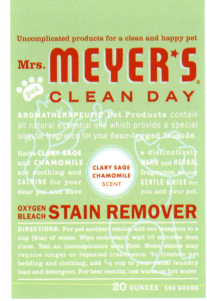

46 3 64

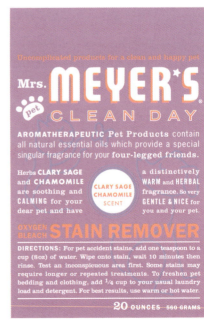

87 94 6

54 Color Harmony: Layout

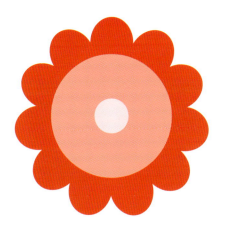

MAMMA GUN SÄGER:
TA EN PAUS...

3 8 6

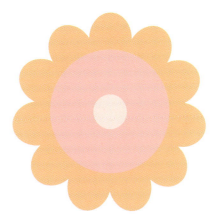

MAMMA GUN SÄGER:
TA EN PAUS...

7 16 22

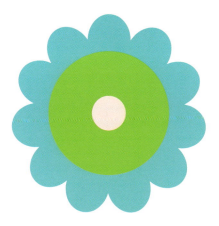

MAMMA GUN SÄGER:
TA EN PAUS...

44 8 61

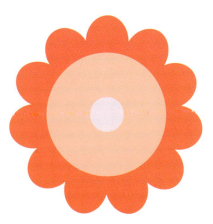

MAMMA GUN SÄGER:
TA EN PAUS...

96 5 15

romantic

earthy

The painted desert, fresh fruits and vegetables, simple nature—the colors that define these are the colors of the earth itself. From the warmth of the red earth, to the turquoise of the American Southwest, to sun gleaming on golden fields of wheat, earth colors connote reliable strength and a simple life. Using attractive and rich earthy colors lends similar qualities to the subject matter.

When a humble, earth-conscious message is needed, an earthy color palette helps to convey a connectedness to the planet.

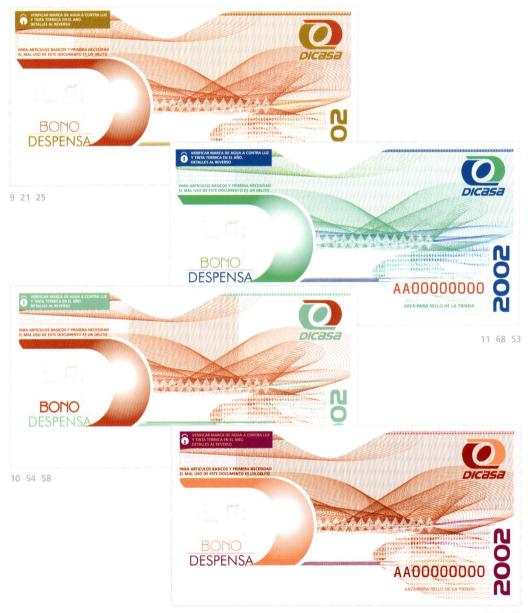

9 21 25

11 68 53

10 54 58

91 1 13

See Process Color Formulas on page 236 for CMYK values of colors shown

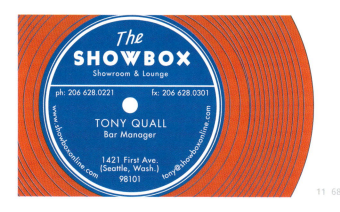

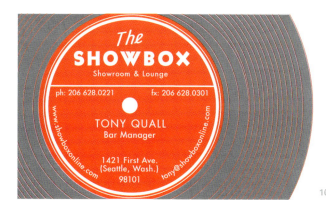

earthy

earthy

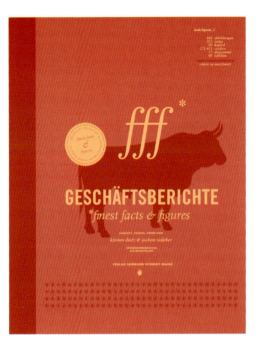

1 10 21

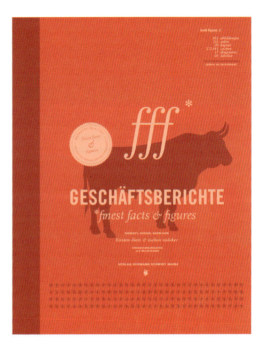

9 11 14

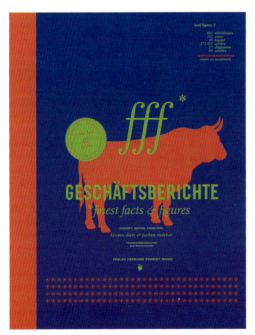

74 10 42

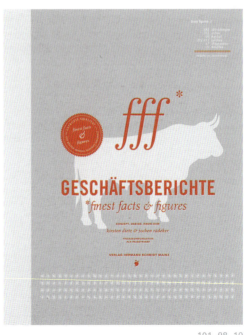

101 98 10

58 Color Harmony: Layout

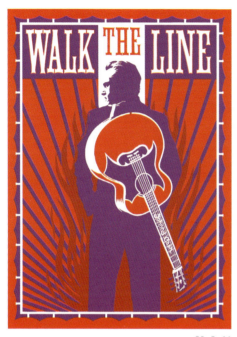
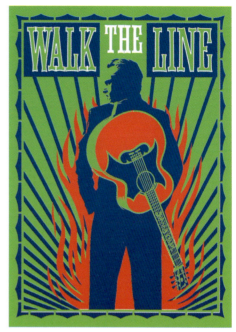

earthy

90 2 11

43 73 11

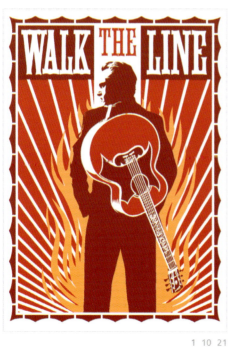
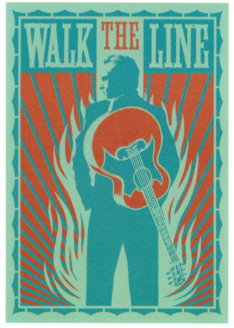

1 10 21

10 54 58

earthy

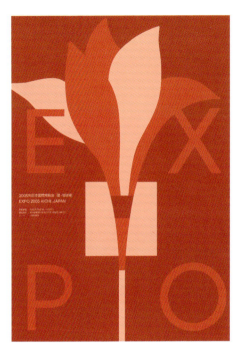
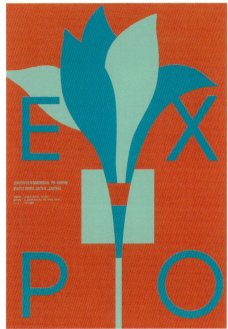

9 10 14 10 54 58

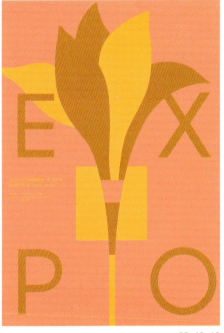
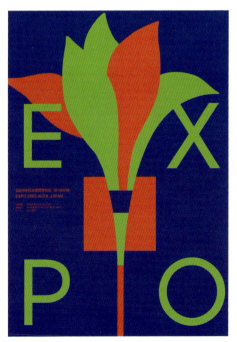

28 13 18 10 42 74

60 Color Harmony: Layout

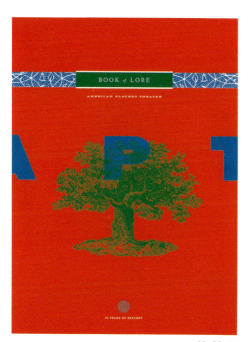

49 66 11

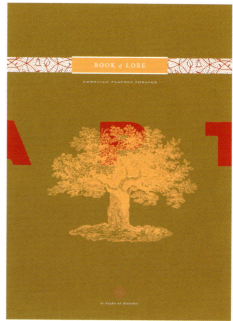

10 21 25

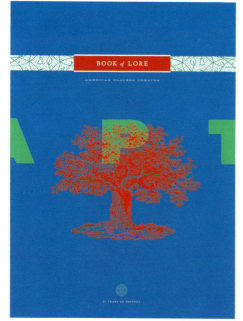

11 53 68

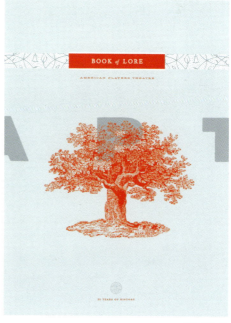

101 98 11

earthy

earthy

9 21 25

10 70

74 10 42

91 1 13

earthy

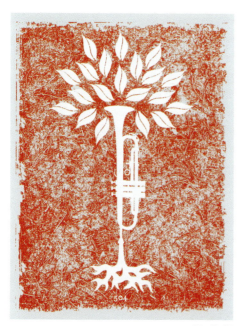

98 10 97

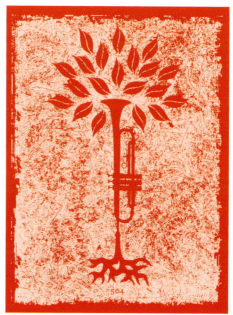

16 11

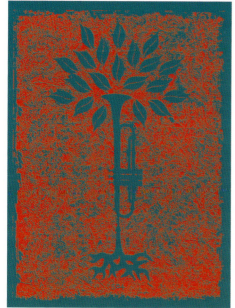

57 11

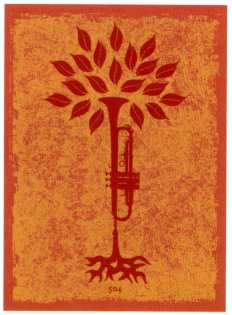

1 10 19

earthy

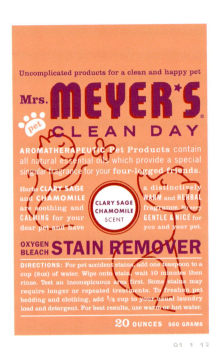
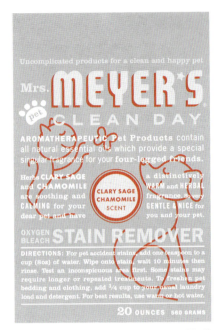
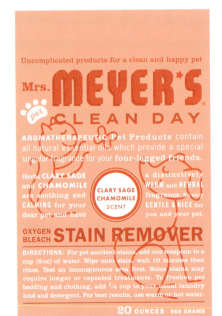
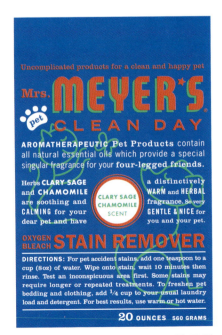

64 Color Harmony: Layout

earthy

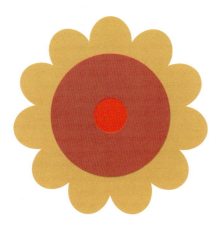

,, MAMMA GUN SÄGER:
TA EN PAUS...

3 9 19

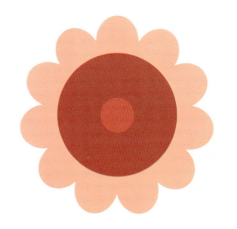

,, MAMMA GUN SÄGER:
TA EN PAUS...

9 14 10

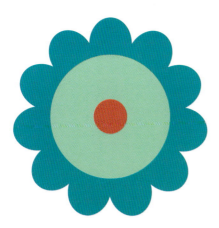

,, MAMMA GUN SÄGER:
TA EN PAUS...

10 54 58

,, MAMMA GUN SÄGER:
TA EN PAUS...

43 73 11

friendly

Turquoise hues, coupled with deep orange and purples, conjure images of the American Southwest, a place defined by warm sun and welcoming people. Without being overbearing, these energetic and highly visible colors extend an invitation to passersby. Orange, in particular, connotes friendliness—which is perhaps why so many of America's first fast-food restaurants turned to this color palette.

The yellows and bright reds of this group may at times seem more suited to utility—safety colors easily seen from a distance, friendly guidance to direct and protect us.

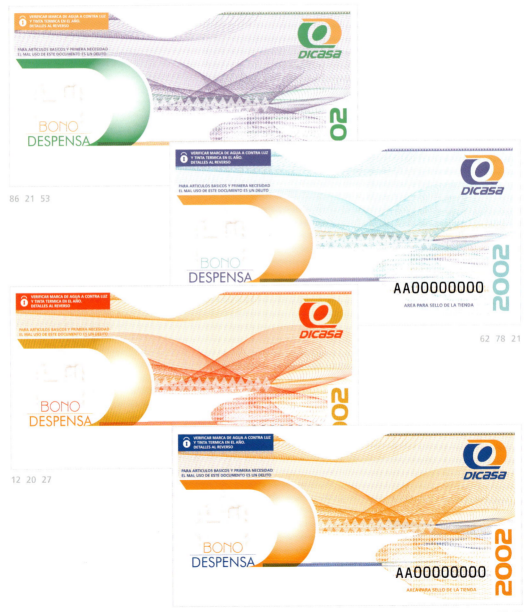

86 21 53

62 78 21

12 20 27

68 20

Color Harmony: Layout See Process Color Formulas on page 236 for CMYK values of colors shown

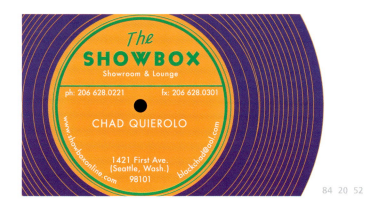

84 20 52

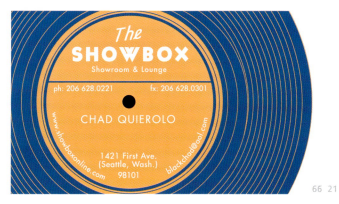

66 21

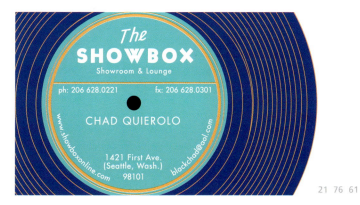

21 76 61

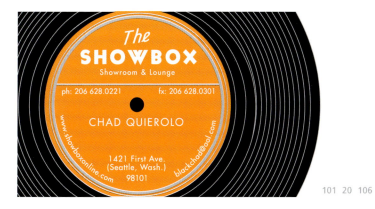

101 20 106

friendly

friendly

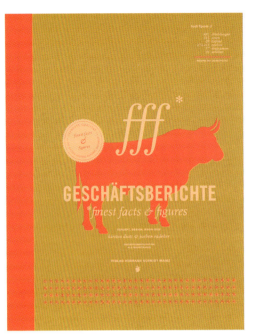

12 22 26

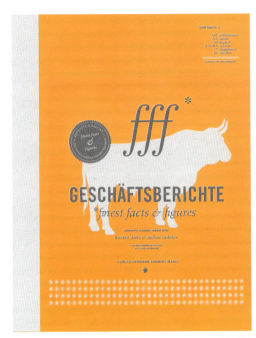

20 98 104

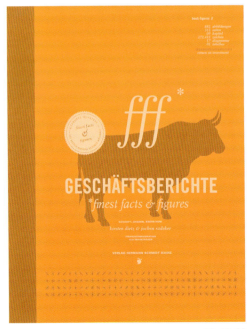

23 18 20

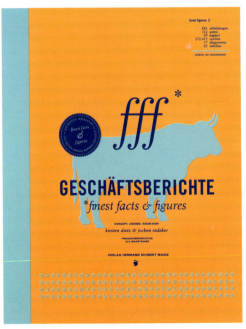

74 20 62

68 Color Harmony: Layout

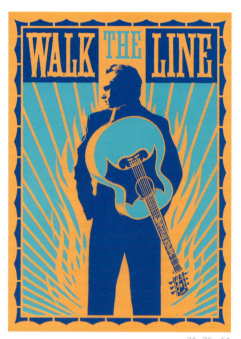
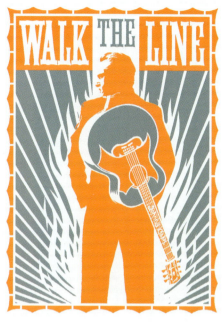
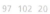

friendly

21 76 61

97 102 20

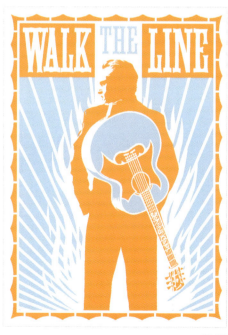
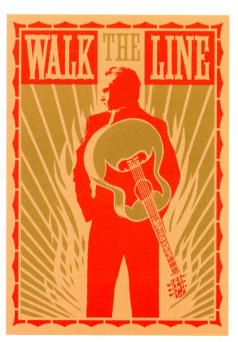

72 21

12 22 26

friendly

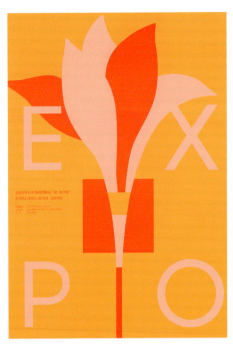

4 14 20

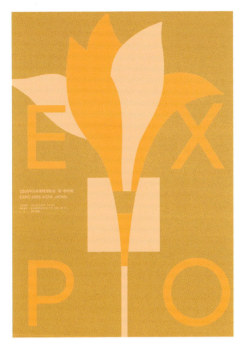

19 22 20

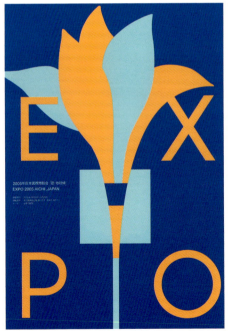

74 20 62

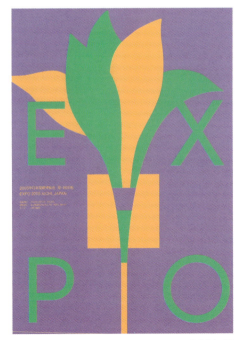

86 21 53

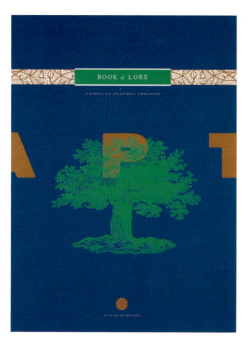
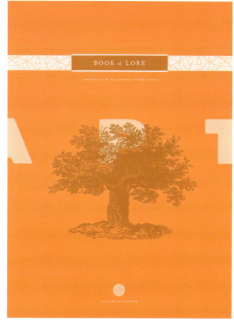
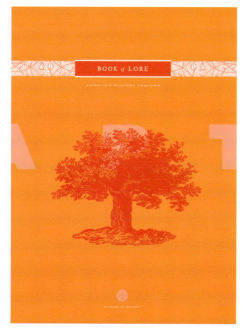
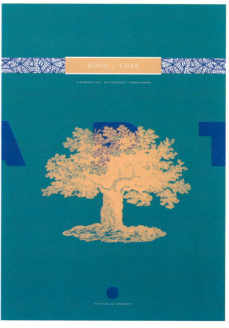

friendly

81 17 50

18 23 20

4 14 20

58 76 22

friendly

23 20

65 18

72 21

59 21

friendly

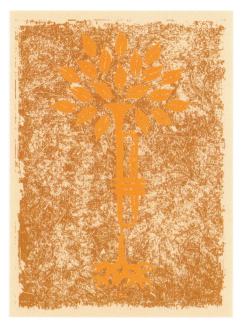

18 23 20

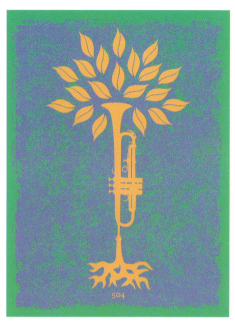

86 21 53

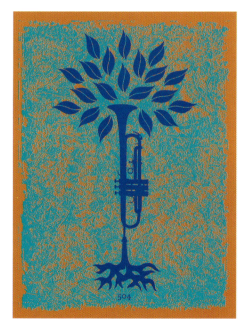

59 75 18

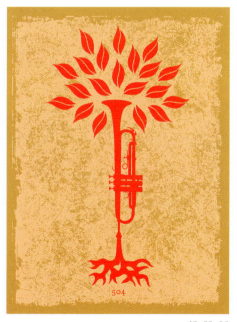

12 22 26

friendly

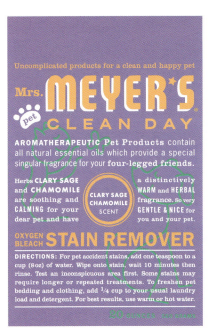

86 21 53

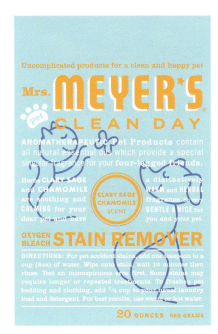

78 20 63

7 16 20

97 102 20

74　Color Harmony: Layout

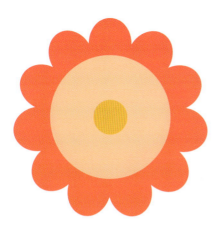

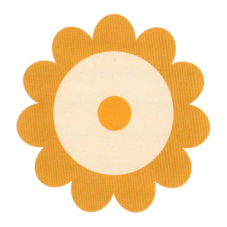

MAMMA GUN SÄGER:
TA EN PAUS...

12 22 26

MAMMA GUN SÄGER:
TA EN PAUS...

18 23 20

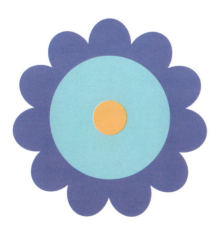

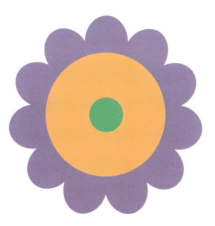

MAMMA GUN SÄGER:
TA EN PAUS...

62 78 21

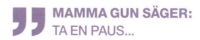
MAMMA GUN SÄGER:
TA EN PAUS...

86 21 53

soft

Tints of warm peach and orange, flooded with light, come to you softly. Like the perfection of a sun-drenched kitchen filled with succulent food, soft colors remind us of slow Sunday mornings. The easy cheerfulness of these colors conjures the nutritious sweetness of fresh fruit nectar. Combined with tints of violet, green, and blue, they form a more resolute stance, but one that invites without effort. Clear-minded and natural, soft colors convey a sense of calm that is reminiscent of some of life's most poignant moments.

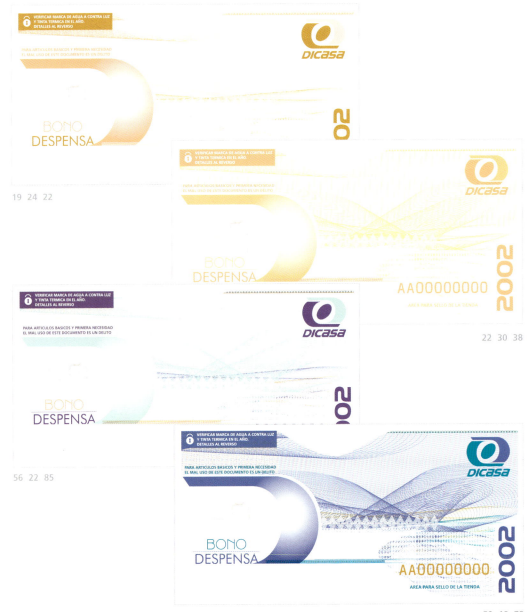

19 24 22

22 30 38

56 22 85

59 19 78

See Process Color Formulas on page 236 for CMYK values of colors shown

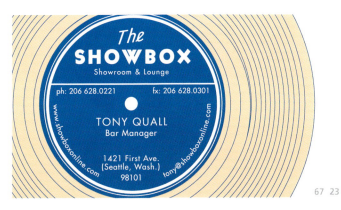

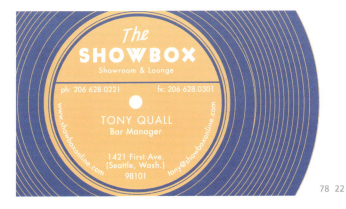

soft

soft

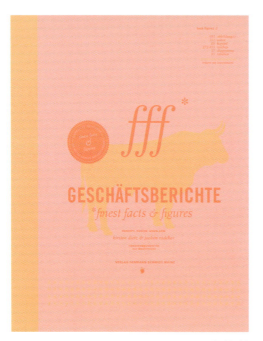

7 13 22

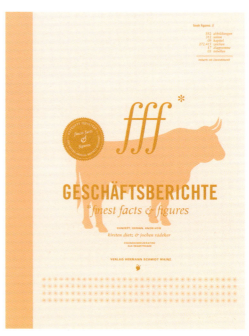

19 24 22

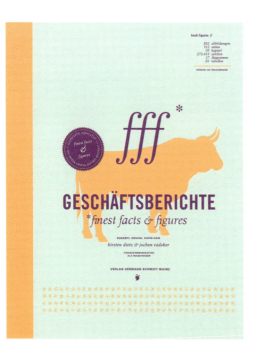

56 22 85

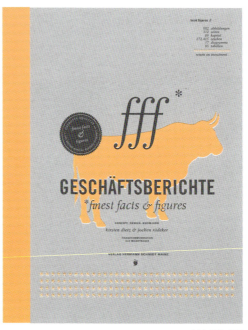

101 22 105

Color Harmony: Layout

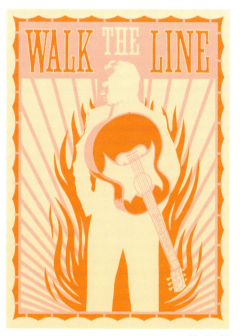

15 20 31

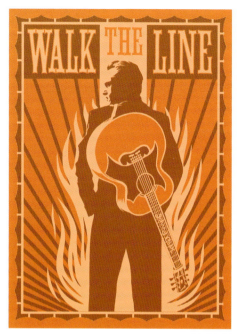

17 19 22

soft

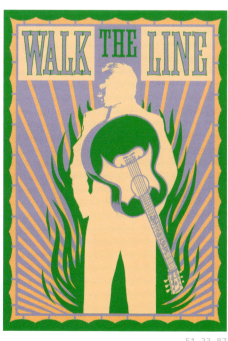

51 23 87

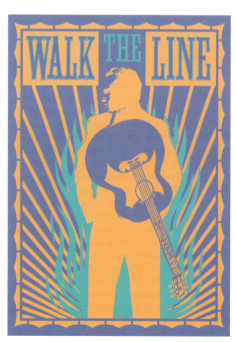

61 22 79

soft

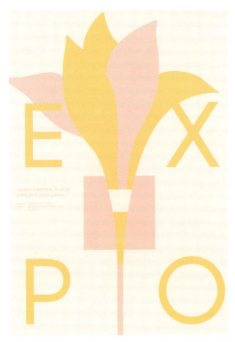
15 24 29

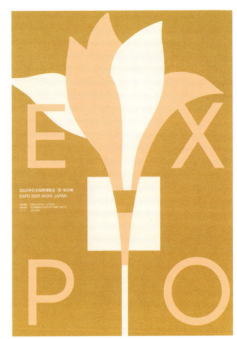
19 24 22

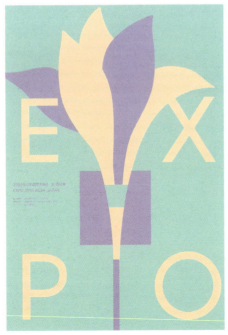
55 23 87

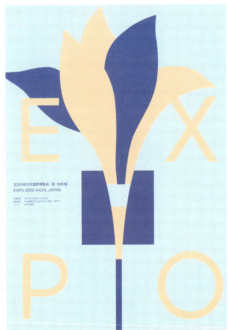
64 23 78

80 Color Harmony: Layout

soft

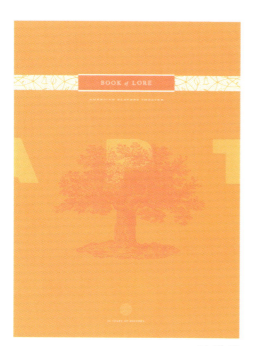

14 22 30

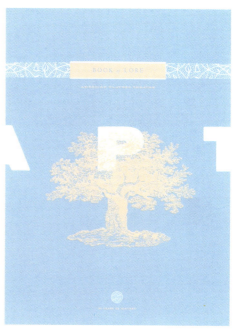

72 24

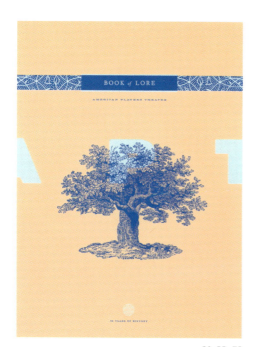

64 23 78

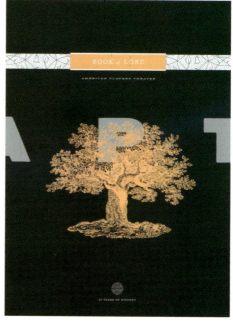

101 22 105

81

soft

17 22

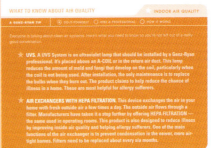

19 24 22

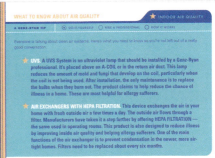

62 22 78

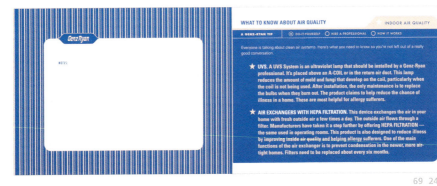

69 24

82 Color Harmony: Layout

soft

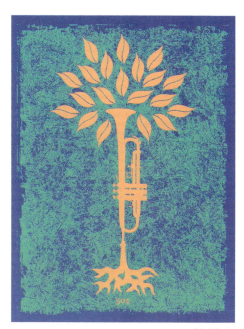

54 22 86

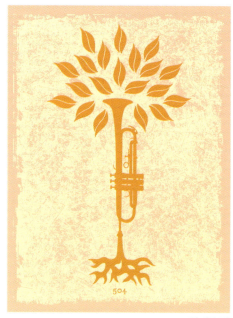

23 27 39

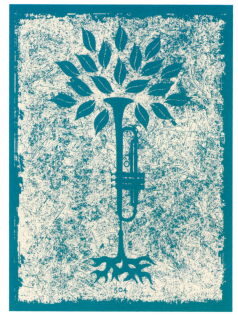

59 24

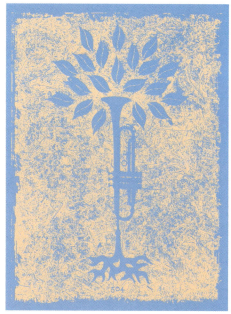

71 23

soft

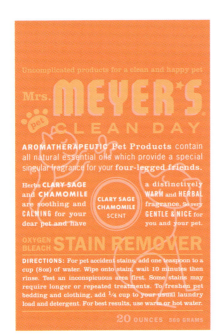

7 13 22

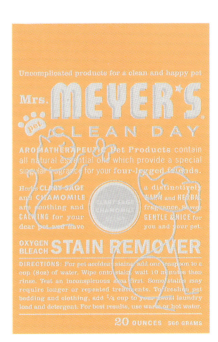

99 98 22

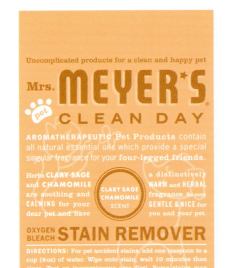

23 18 22

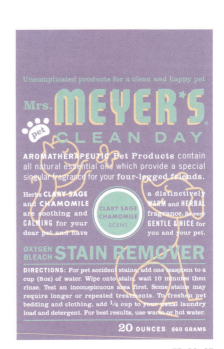

55 23 87

84　Color Harmony: Layout

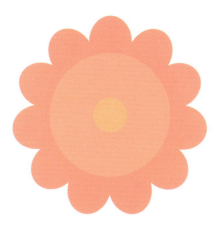

MAMMA GUN SÄGER:
TA EN PAUS...

6 14 22

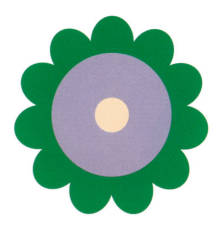

MAMMA GUN SÄGER:
TA EN PAUS...

51 23 87

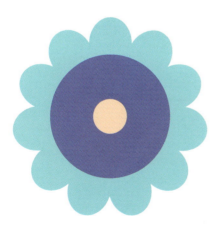

MAMMA GUN SÄGER:
TA EN PAUS...

62 78 23

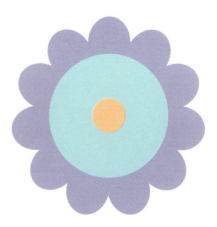

MAMMA GUN SÄGER:
TA EN PAUS...

63 22 80

soft

welcoming

Yellow-orange and amber are perhaps the most welcoming of colors. Forward and confident, they possess an inherent radiance.

When aligned with their complements, they convey a pleasing and powerful—but never brash—feeling. When used solo, hues and tints of a single color present a sense of elegance. Yet as a whole, this group goes beyond mere elegance, beaming as if the sun god himself were descending. These are the colors of celebration, warmth, beauty. Like the morning sun, they bring the promise of a new day.

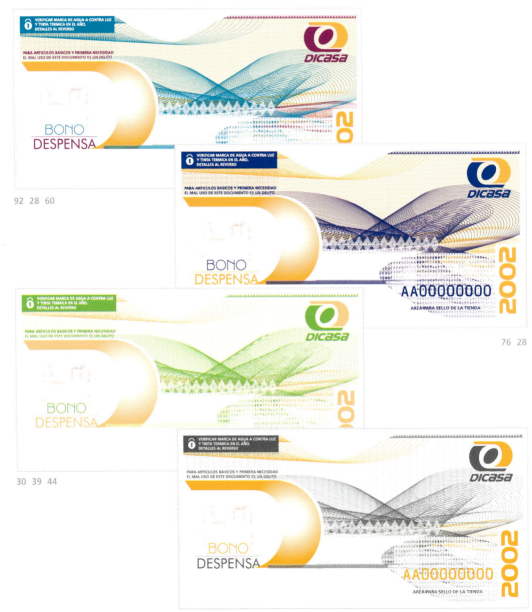

92 28 60

76 28

30 39 44

28 98 104

See Process Color Formulas on page 236 for CMYK values of colors shown

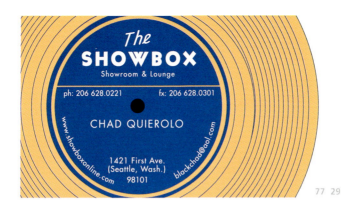

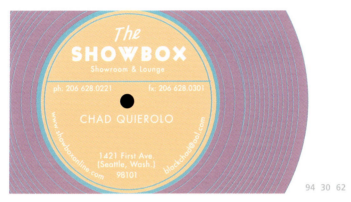

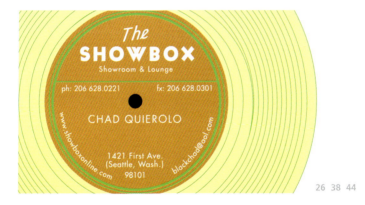

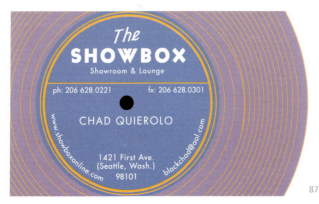

welcoming

welcoming

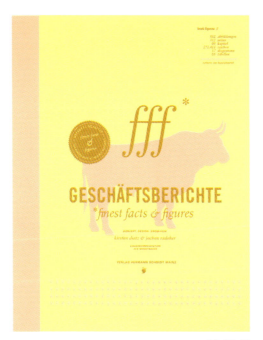

23 26 38

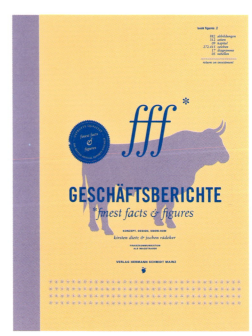

30 68 87

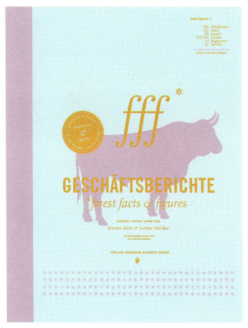

95 27 64

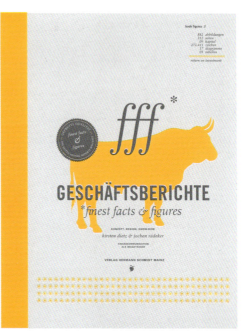

28 98 104

Color Harmony: Layout

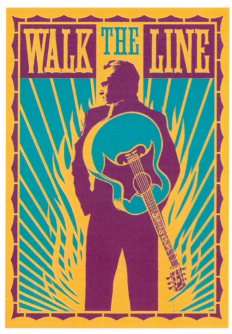

92 28 60

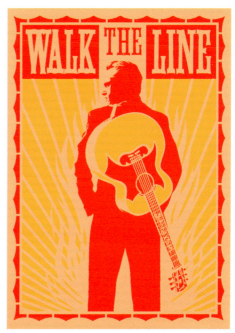

12 22 28

welcoming

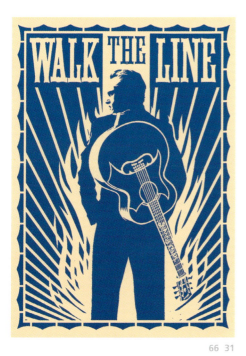

66 31

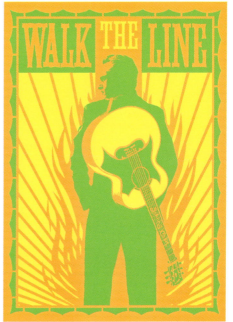

28 36 44

welcoming

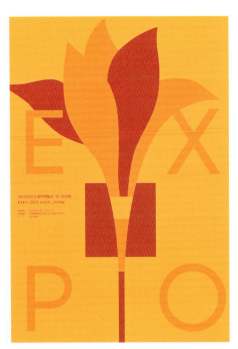
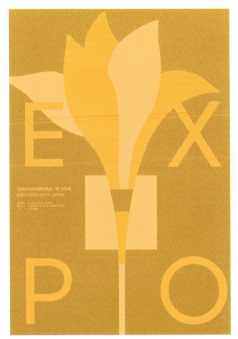

10 20 28 26 29 28

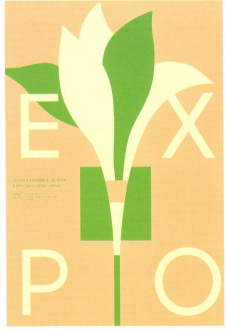
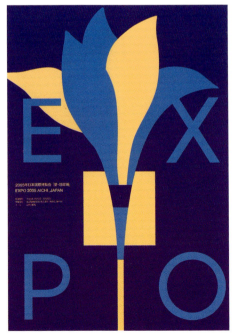

30 39 44 82 69 29

90 Color Harmony: Layout

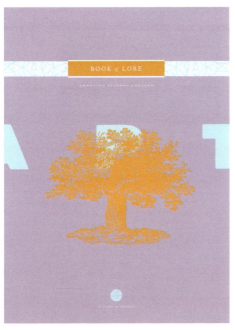

95 27 64

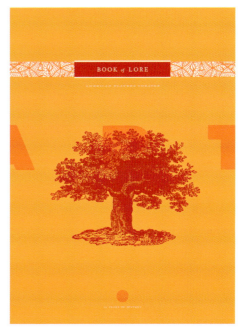

10 20 28

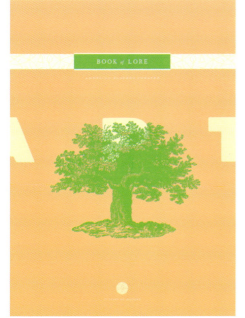

30 39 44

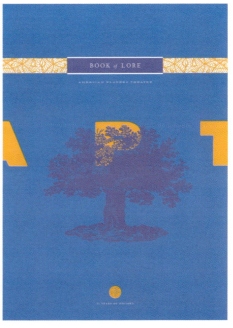

70 28 86

welcoming

welcoming

78 26

31 27

65 30

23 26 38

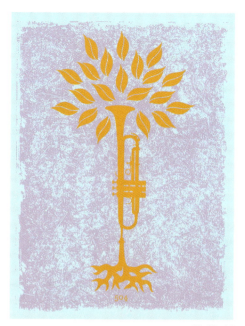

95 27 64

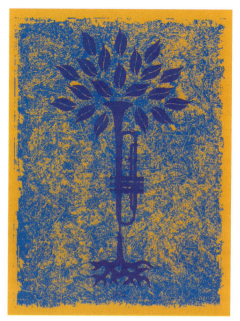

85 78 27

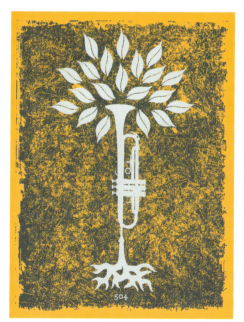

28 98 104

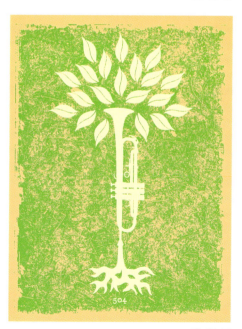

30 39 44

welcoming

welcoming

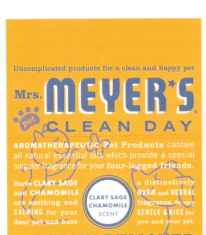

87 70 28

30 68 87

94 30 62

27 31 28

94 Color Harmony: Layout

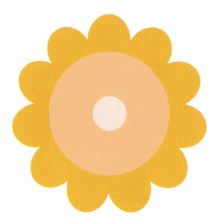

MAMMA GUN SÄGER:
TA EN PAUS...

16 22 27

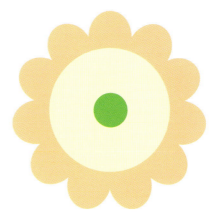

MAMMA GUN SÄGER:
TA EN PAUS...

30 39 44

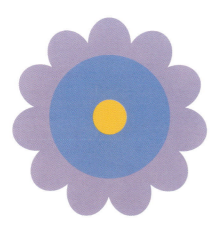

MAMMA GUN SÄGER:
TA EN PAUS...

87 70 28

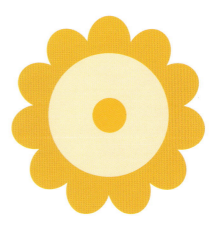

MAMMA GUN SÄGER:
TA EN PAUS...

27 31 28

welcoming

elegant

Pale tints of yellow and purple, understated and filled with light, paint a palette of elegance that conveys status. From delicate yellows and pale yellow-greens to orange-browns, these are the colors of refinement.

Consider the fragile blossom of an iris in spring, the distinctive home decorated as a mother could only hope for, or Sunday tea in the garden. Such moments could have no more dear a companion than these elegant colors.

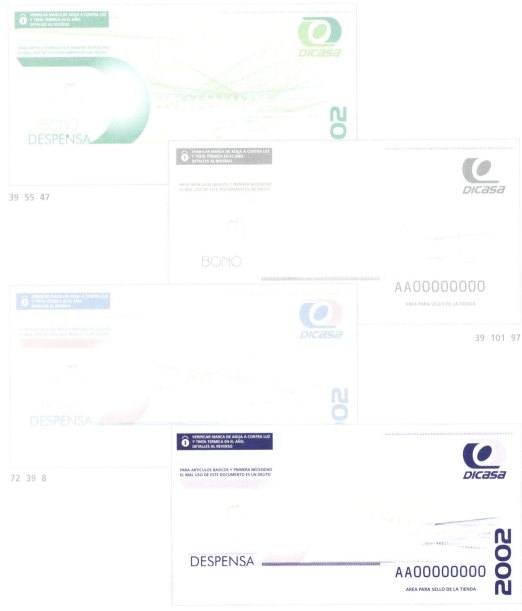

39 55 47

39 101 97

72 39 8

77 96 40

See Process Color Formulas on page 236 for CMYK values of colors shown

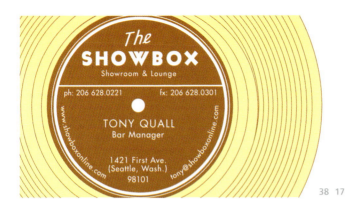

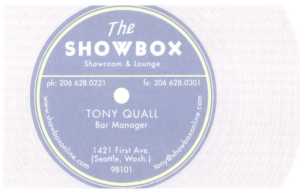

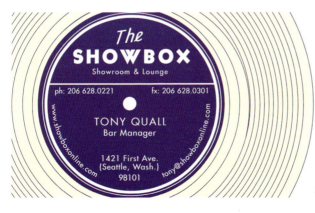

elegant

elegant

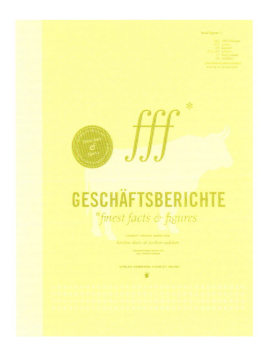

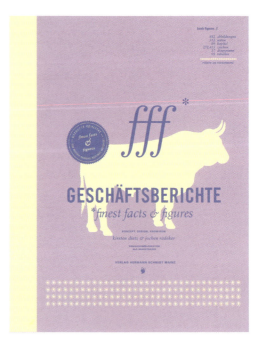

38 34 39

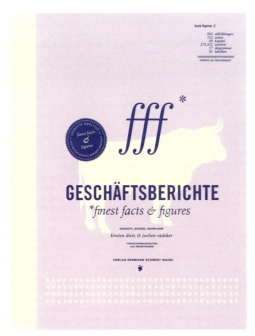

79 39 95

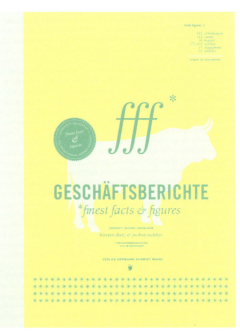

77 96 40

38 48 54

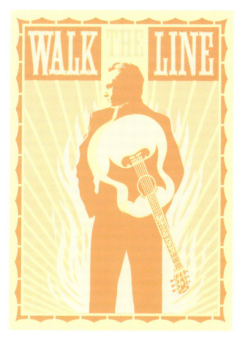
22 32 39

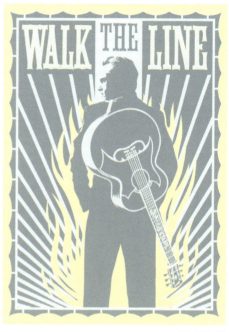
39 101 97

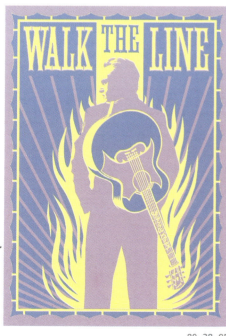
80 38 95

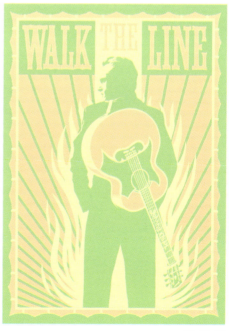
31 39 46

elegant

elegant

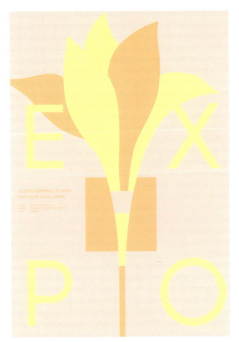
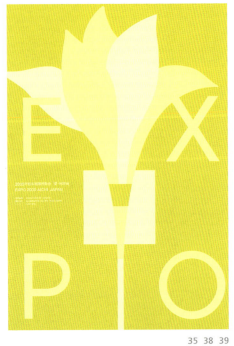

24 30 38　　　　　　　　　　　　　　　　　35 38 39

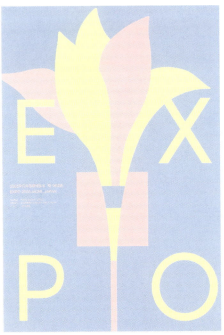
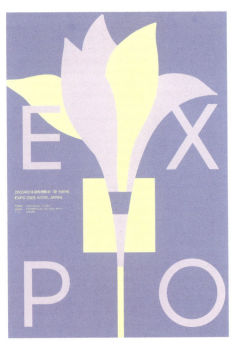

72 39 8　　　　　　　　　　　　　　　　　80 96 39

100　Color Harmony: Layout

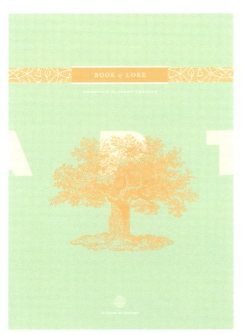

30 40 47

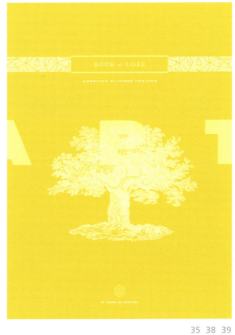

35 38 39

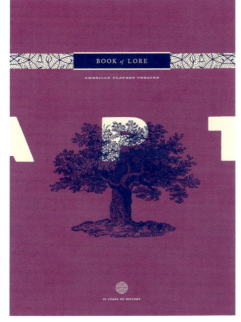

75 40 93

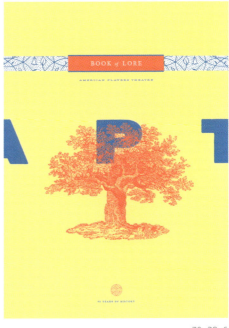

70 38 6

elegant

elegant

80 37 94

38 48 54

85 39

101 39 100

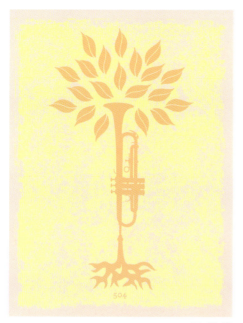

24 30 38

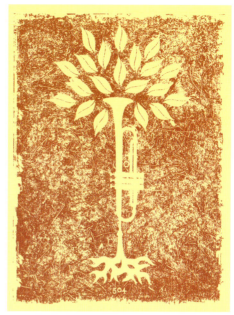

38 18

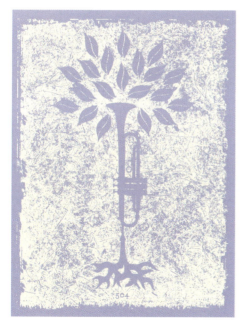

88 40

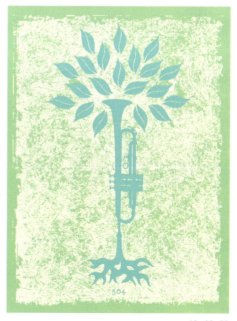

40 46 55

elegant

elegant

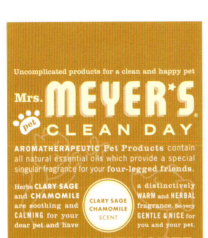

40 26

78 39 95

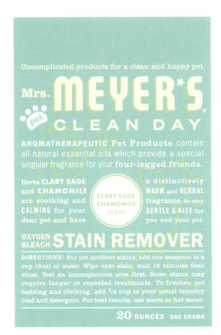

72 39 8

40 46 55

104 Color Harmony: Layout

40 48 56

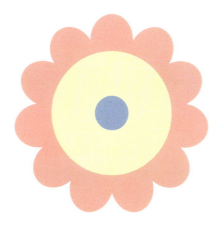

71 39 7

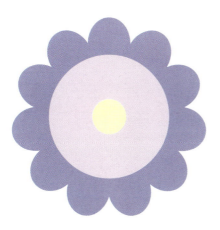

80 39 96

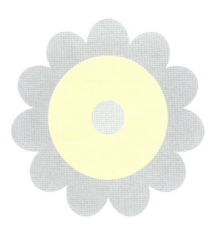

98 99 39

elegant

trendy

There's no question as to what these colors might be: brash, exuberant, intense, playful, and none too concerned about what others might think.

Though these colors can be paired with dark colors for great effect, alone they can feel like natural colors boosted to a new level. From grapefruit pink to brick red, from lavender to eggplant, from celery to pepper green, these trendy colors grab attention. Pale yellows, cool blues, and nutmeg brown-oranges round out this spirited cast. This palette is perfect for glamour, youthfulness, and refreshing life.

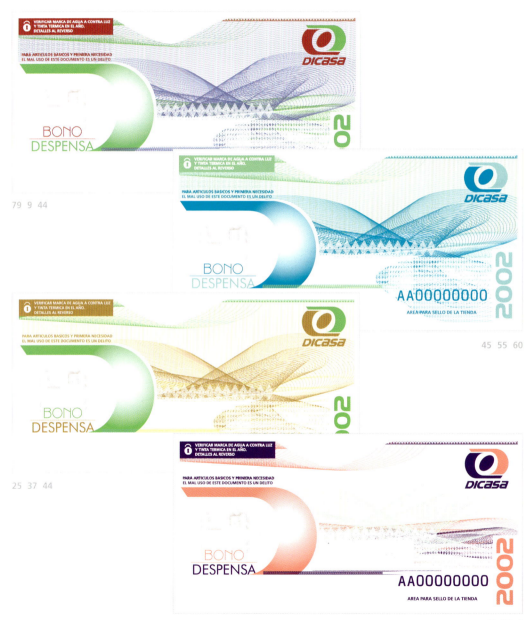

79 9 44

45 55 60

25 37 44

48 84 6

See Process Color Formulas on page 236 for CMYK values of colors shown

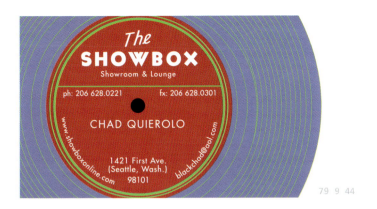

79 9 44

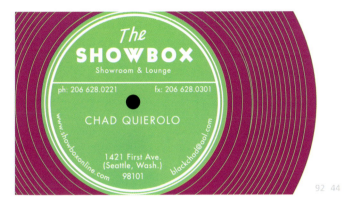

92 44

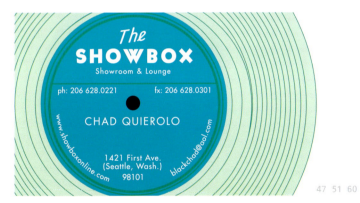

47 51 60

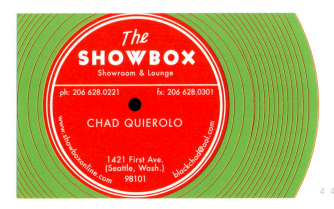

4 44

trendy

trendy

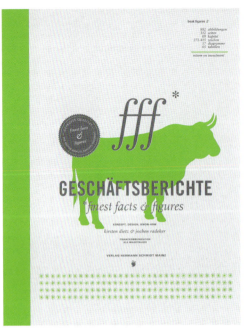

44 98 104

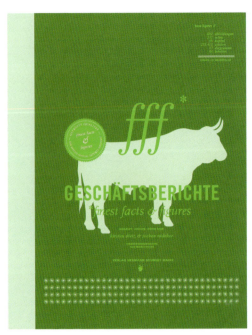

47 41 44

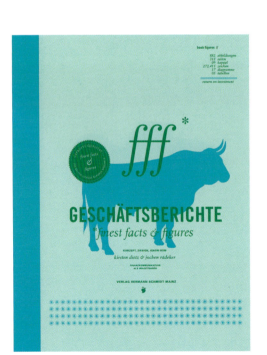

55 50 60

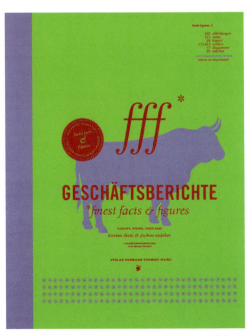

79 9 44

108 Color Harmony: Layout

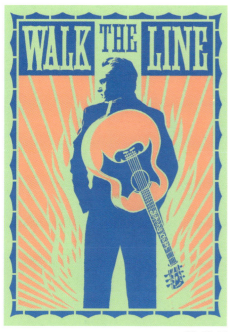

78 14 46

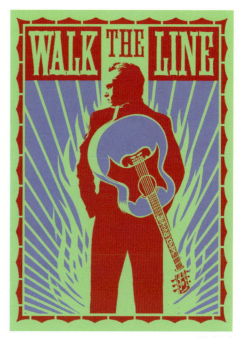

45 86 2

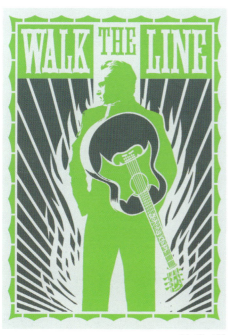

44 98 104

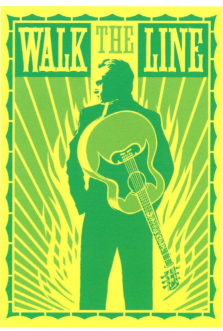

36 44 52

trendy

trendy

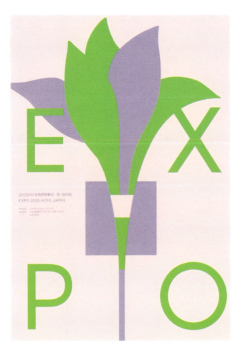
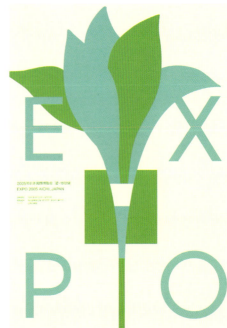

8 44 87

40 54 43

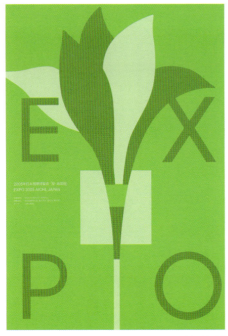
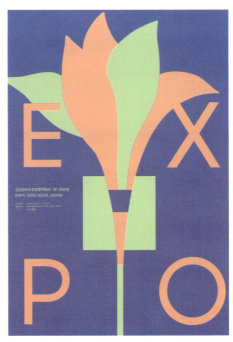

44 42 46

78 14 46

110 Color Harmony: Layout

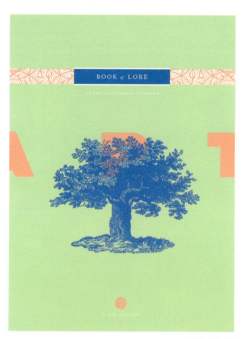

78 14 46

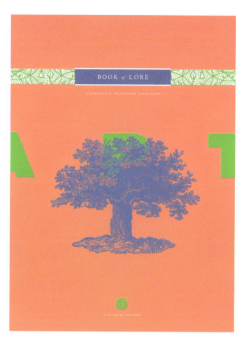

6 86 44

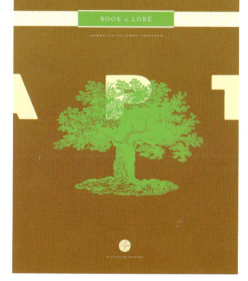

25 39 44

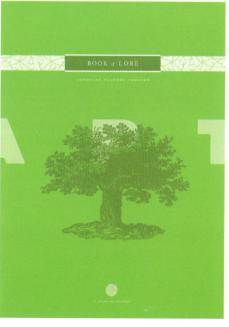

42 46 44

trendy

trendy

91 42

43 48

3 47

8 87 44

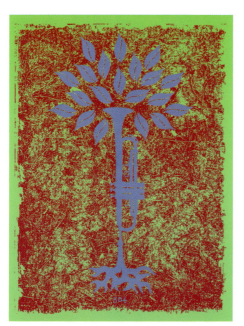

79 9 44

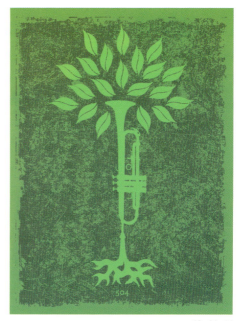

43 41 44

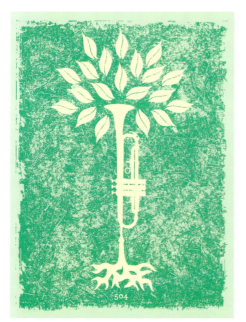

39 47 52

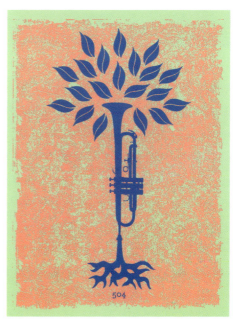

78 14 46

trendy

trendy

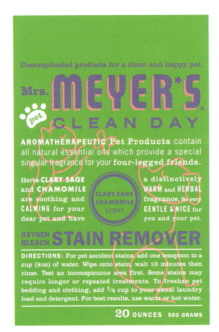

6 86 44

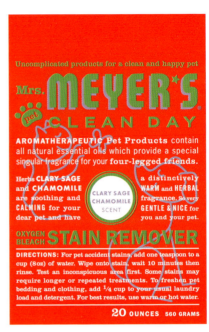

87 42 4

25 39 44

78 14 46

Color Harmony: Layout

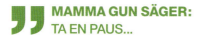
MAMMA GUN SÄGER:
TA EN PAUS...

41 102 104

MAMMA GUN SÄGER:
TA EN PAUS...

79 9 44

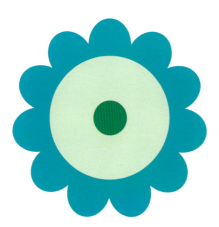

MAMMA GUN SÄGER:
TA EN PAUS...

47 50 60

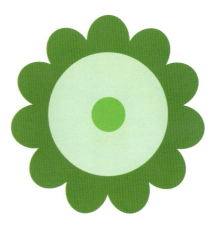

MAMMA GUN SÄGER:
TA EN PAUS...

47 41 44

fresh

Just as the name suggests, this palette recalls nostalgic fruit labels and springtime in the sun—not so hot as to be uncomfortable, but bathed in natural light and the life it brings. Blue, yellow, and green embody the vitality and health that the word "fresh" implies.

Lean to complementary colors, even a drop, to catch the eye. Cool your palette with greens and blues. Spark some heat with reds and orange. Evoke growth with hues from yellows to deep greens. These colors convey healthy abundance and growth itself.

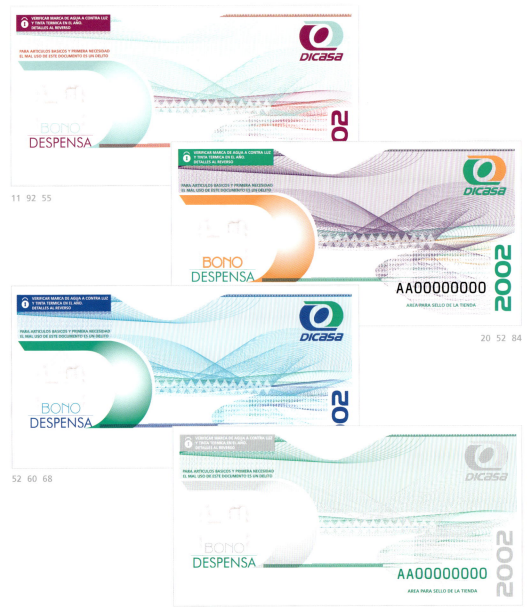

11 92 55

20 52 84

52 60 68

98 100 52

116 Color Harmony: Layout See Process Color Formulas on page 236 for CMYK values of colors shown

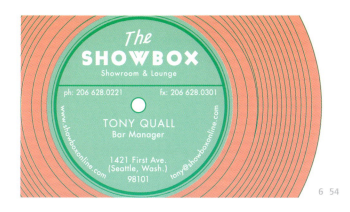

6 54

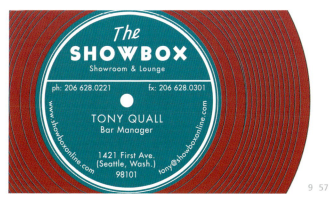

9 57

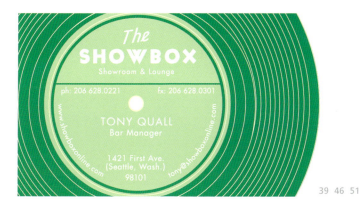

39 46 51

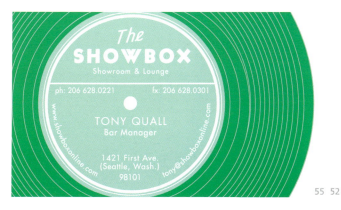

fresh

fresh

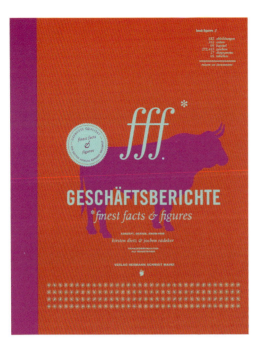

10 92 55

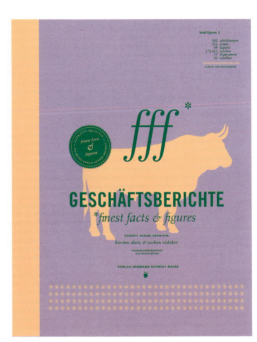

22 49 87

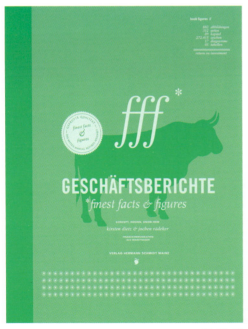

56 53 52

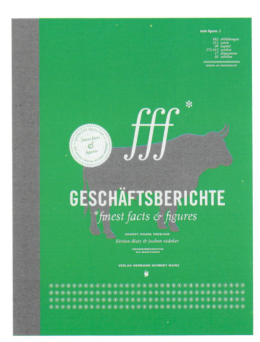

97 102 52

118 Color Harmony: Layout

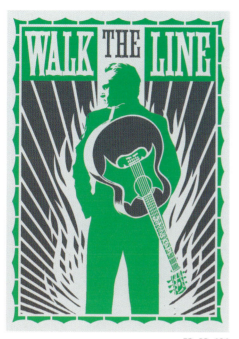
52 98 104

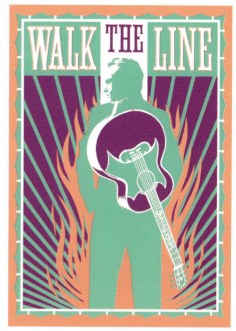
54 92 14

fresh

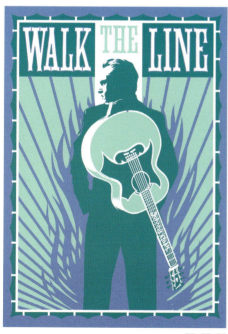
55 58 70

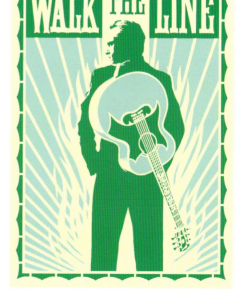
55 51 39

fresh

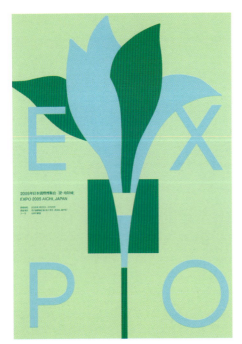

46 50 62

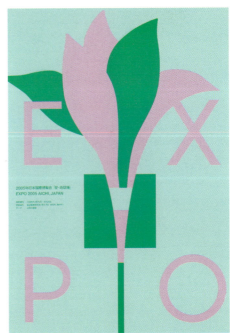

55 95 52

56 53 52

97 102 52

120 Color Harmony: Layout

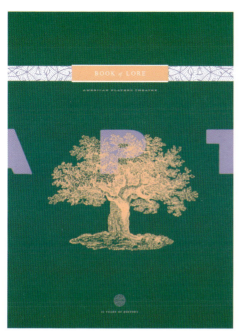

22 49 87

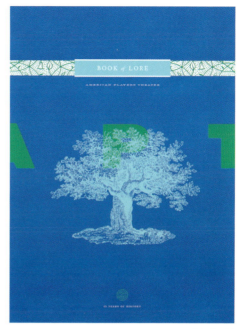

51 62 68

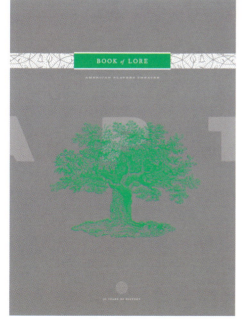

101 52 102

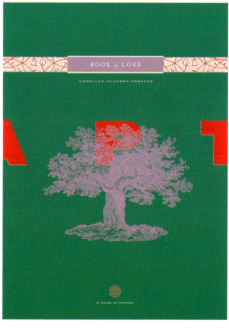

94 50 12

fresh

fresh

22 49 87

49 56

51 62 68

55 95 11

122 Color Harmony: Layout

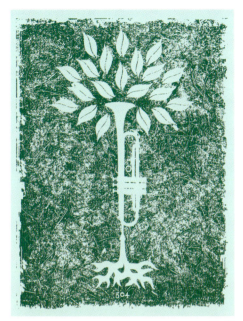

49 56

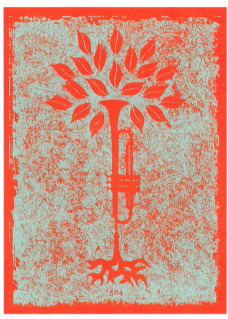

5 55

92 52

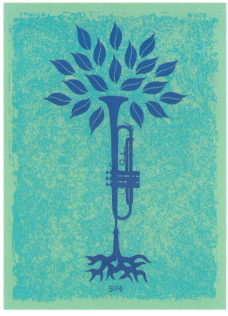

54 60 68

fresh

fresh

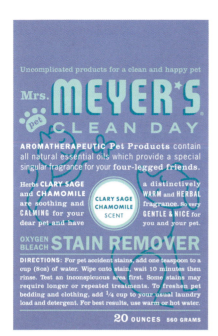

55 58 70

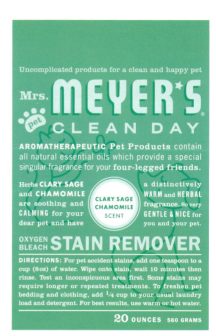

56 53 52

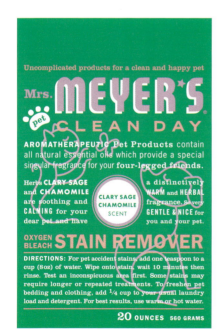

95 52 7

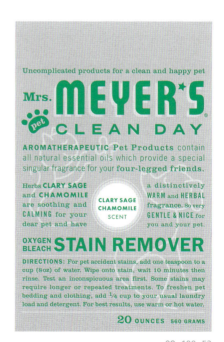

98 100 52

MAMMA GUN SÄGER:
TA EN PAUS...

38 45 52

MAMMA GUN SÄGER:
TA EN PAUS...

47 50 62

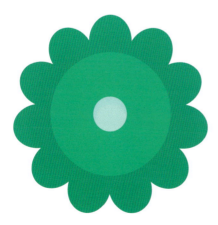

MAMMA GUN SÄGER:
TA EN PAUS...

55 51 52

MAMMA GUN SÄGER:
TA EN PAUS...

52 98 104

traditional

These colors bring to mind solidly built objects in the style of the early twentieth century. They reflect choices that might be made for a distinguished sportsman's club—deepened hues that need no movement or excitement yet promote a rich calmness.

These colors are stable, imbued with life, and lack urgency. They are beautiful with black or metallic and surprise you with how much verve they have given their innate darkness. Though they were once considered animated, they now possess the wisdom associated with savoring the passage of time.

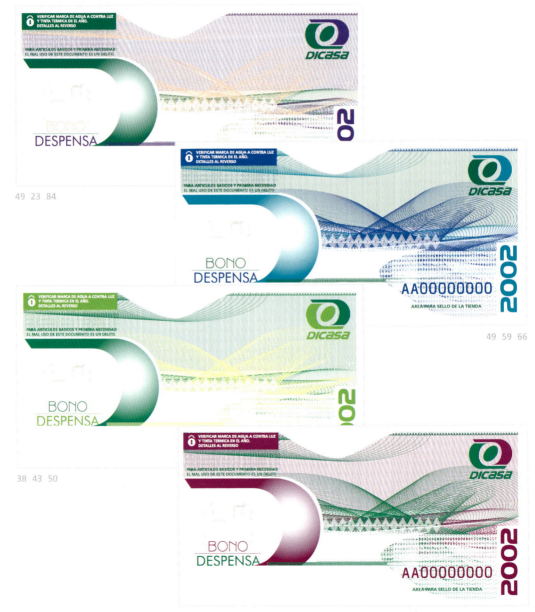

49 23 84

49 59 66

38 43 50

50 90

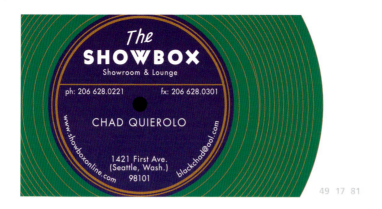

49 17 81

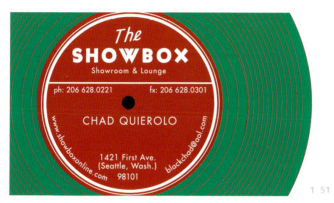

1 51

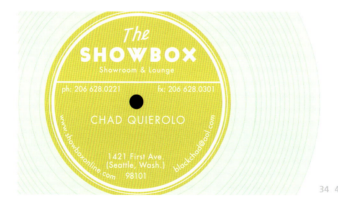

34 47 48

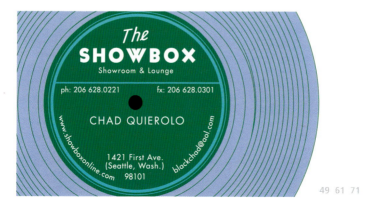

49 61 71

traditional

traditional

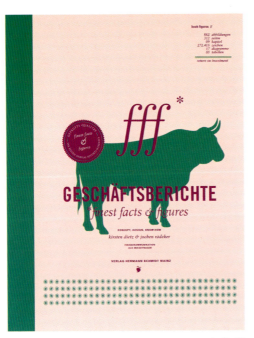

16 49 90

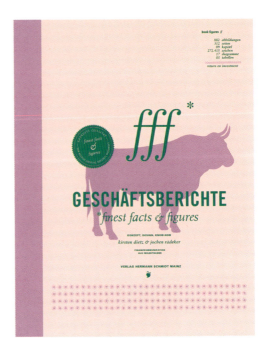

16 94 49

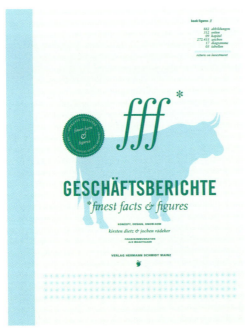

48 50 63

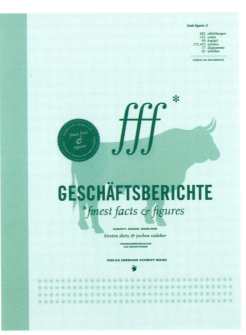

54 56 49

128 Color Harmony: Layout

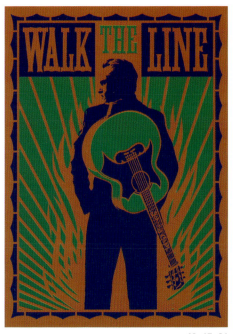
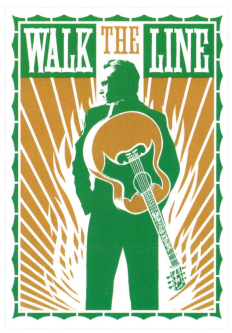

traditional

49 17 81

51 26

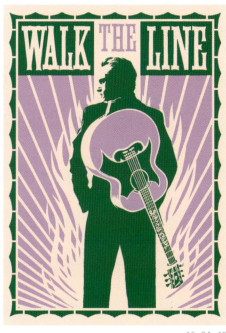
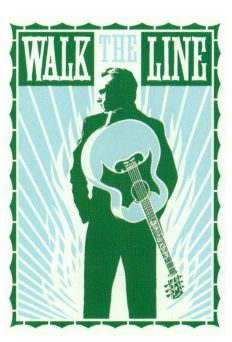

16 94 49

48 50 63

traditional

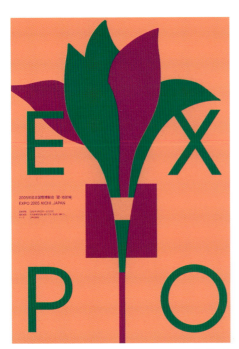
13 49 91

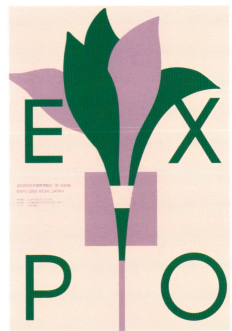
16 94 49

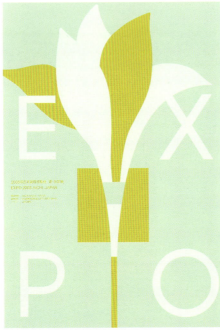
34 47 48

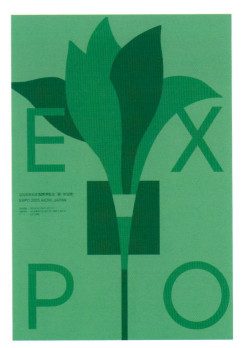
53 51 49

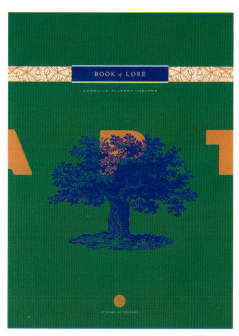

49 19 83

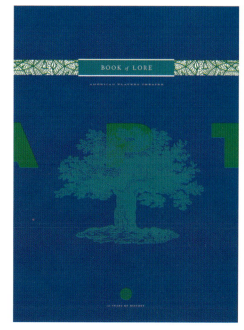

49 57 65

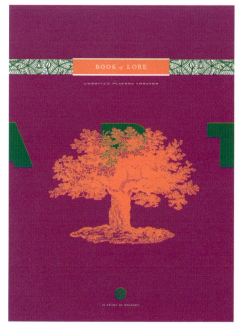

13 49 91

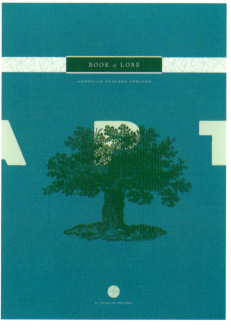

47 49 58

traditional

traditional

132 Color Harmony: Layout

traditional

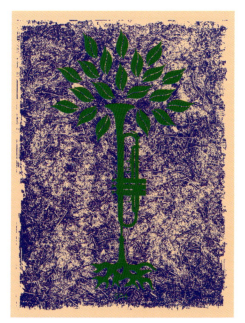

49 23 84

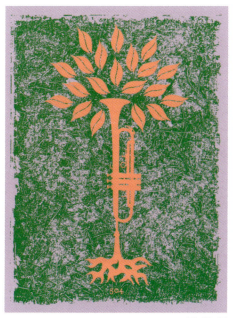

14 50 95

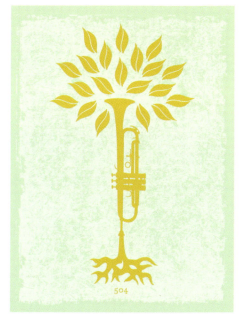

34 47 48

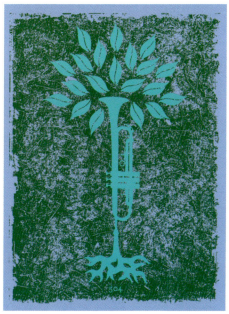

49 61 71

traditional

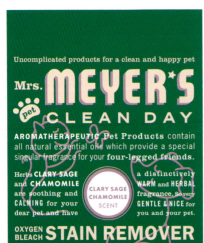

16 94 49

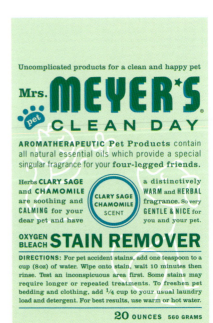

47 49 58

15 50 89

98 100 49

134 Color Harmony: Layout

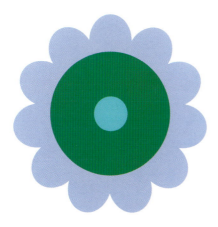

MAMMA GUN SÄGER:
TA EN PAUS...

49 61 71

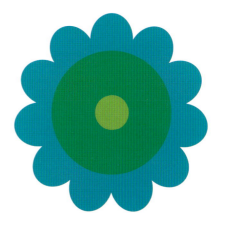

MAMMA GUN SÄGER:
TA EN PAUS...

42 50 58

traditional

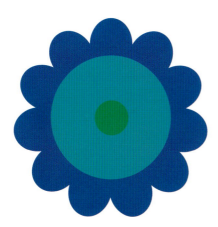

MAMMA GUN SÄGER:
TA EN PAUS...

50 58 66

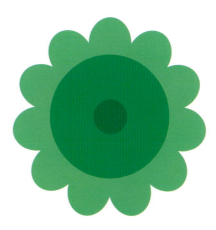

MAMMA GUN SÄGER:
TA EN PAUS...

53 51 49

refreshing

Relief from a parched landscape; an antidote to barrenness—refreshing colors grant a respite from the scorching heat of the Sun.

Cool blue-greens and teals are enriched when paired with red-orange. As vivid as tomatoes in a rustic teal bowl—the perfect still life—these colors provide an oasis. Though primarily green to blue to purple, refreshing colors can also delve into brighter reds and oranges. They convey calm over exuberance, peace over celebration, and contentment over desire.

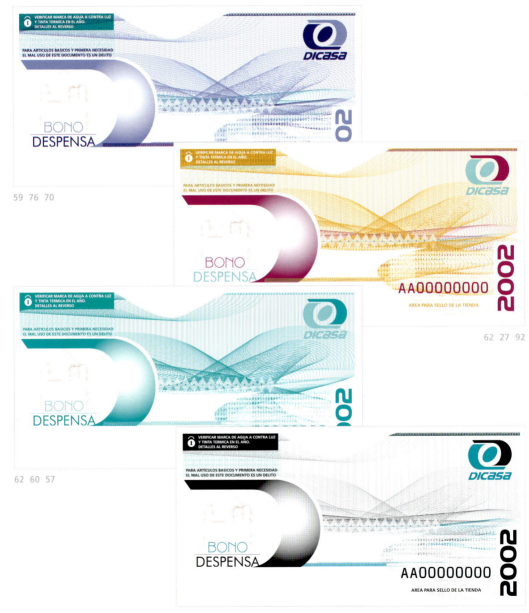

59 76 70

62 27 92

62 60 57

101 60 106

See Process Color Formulas on page 236 for CMYK values of colors shown

16 64

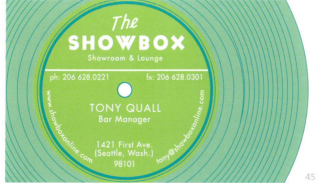

45 54 60

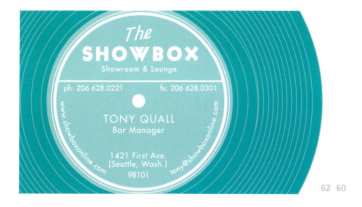

62 60

refreshing

98 100 60

refreshing

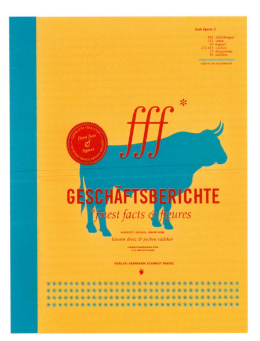

3 60 28

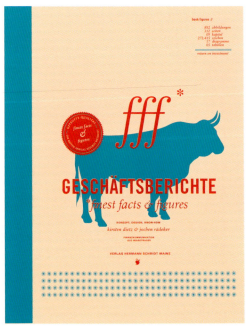

23 3 59

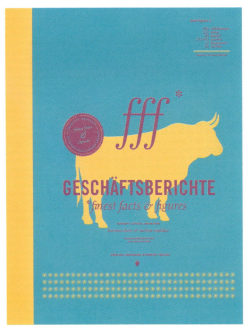

61 29 93

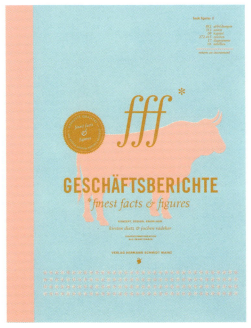

63 7 19

Color Harmony: Layout

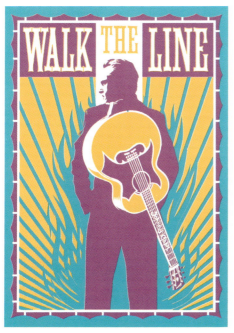

61 29 93

62 6 23

refreshing

62 57 60

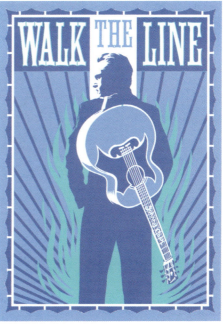

62 71 79

refreshing

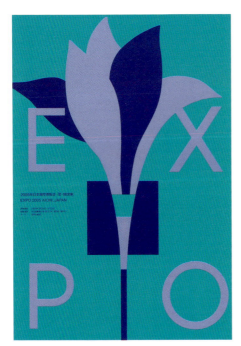

59 70 76

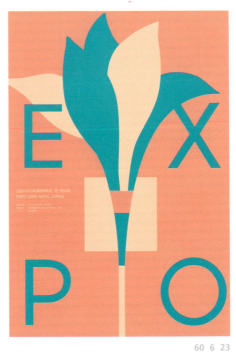

60 6 23

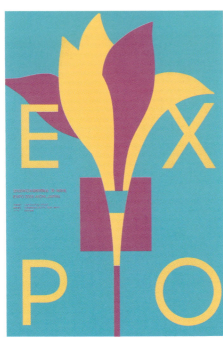

61 29 93

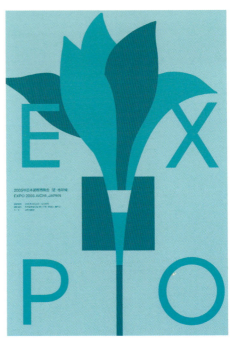

62 57 60

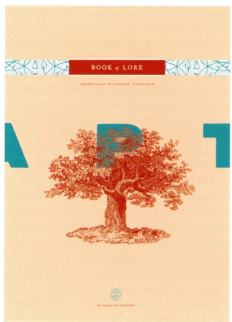

23 3 59

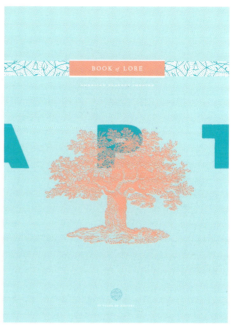

6 63 60

62 71 79

60 98 104

refreshing

refreshing

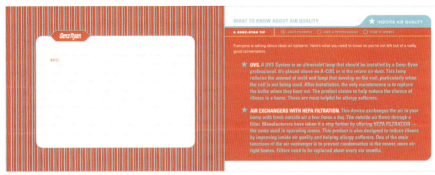

11 62

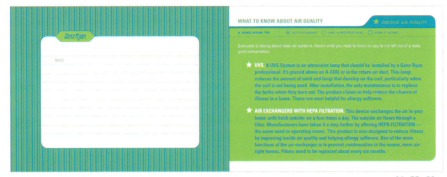

44 53 60

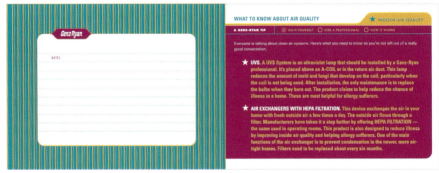

59 27 91

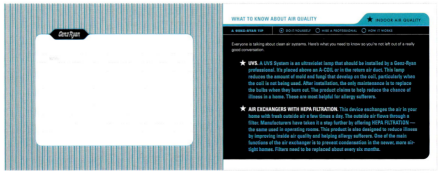

101 60 106

142 Color Harmony: Layout

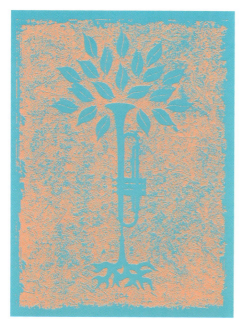

14 61

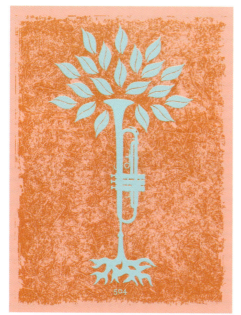

63 7 19

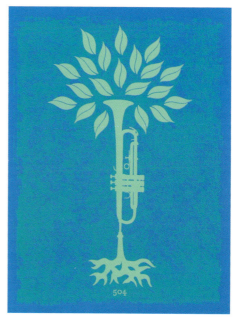

54 59 69

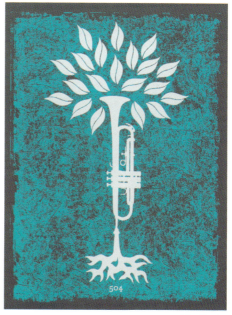

60 98 104

refreshing

refreshing

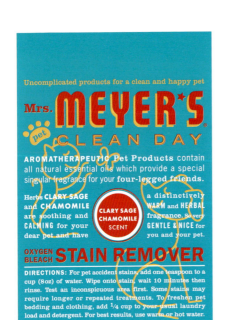

3 60 28

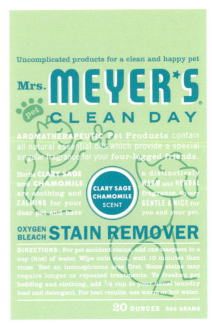

46 53 59

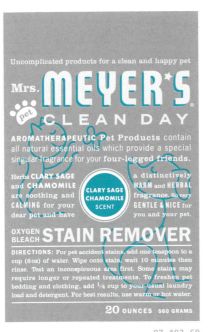

97 102 60

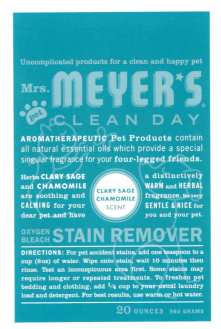

62 61 60

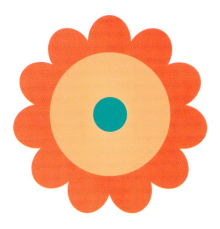

MAMMA GUN SÄGER:
TA EN PAUS...

5 60 22

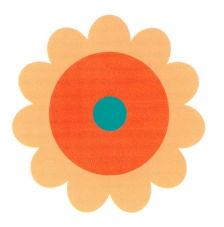

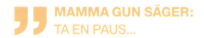
MAMMA GUN SÄGER:
TA EN PAUS...

22 5 60

MAMMA GUN SÄGER:
TA EN PAUS...

54 61 71

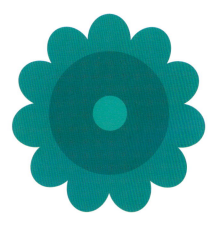

MAMMA GUN SÄGER:
TA EN PAUS...

58 57 60

tropical

The tranquility of cool blue-to-turquoise hues, and the warmth of yellow to red, reflect the tropics. The blue-green colors are soothing and refreshing. The yellow-reds are bright, yet tranquil. Ease and comfort define the tropics as well as the colors. They define a world all their own, a haven far away from the churning concerns of a busy life. Pairing deep red with turquoise creates a vibrant and nearly shocking visual. Yet, to lay these on a field of white softens them, creating an underlying strength that still has the casual sway of the beach or the sea.

Choose these colors to evoke slow ease, water, or sun-drenched places.

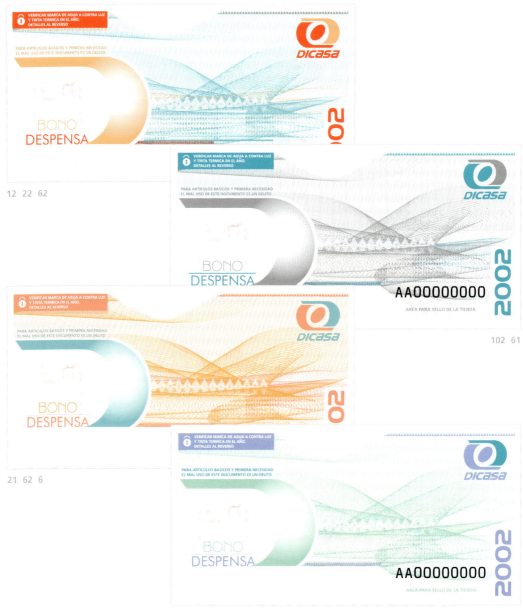

12 22 62

102 61

21 62 6

55 61 71

See Process Color Formulas on page 236 for CMYK values of colors shown

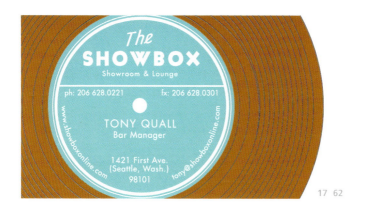

17 62

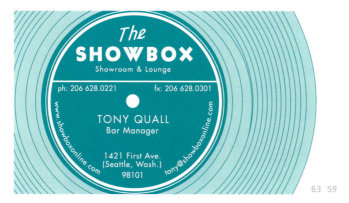

63 59

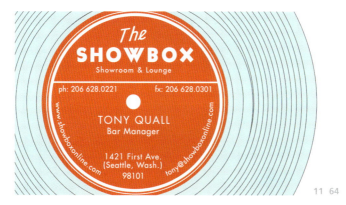

11 64

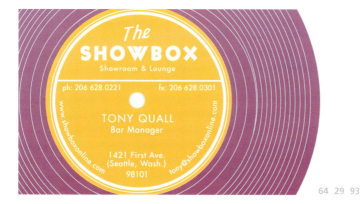

64 29 93

tropical

tropical

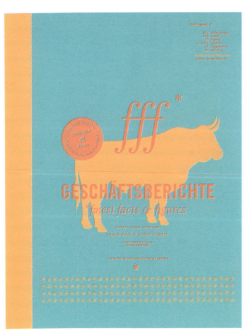

6 62 22

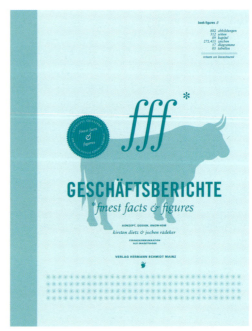

59 64 62

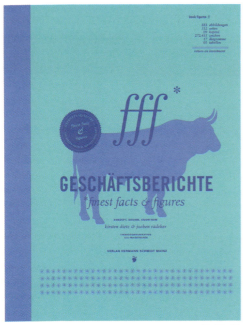

62 70 78

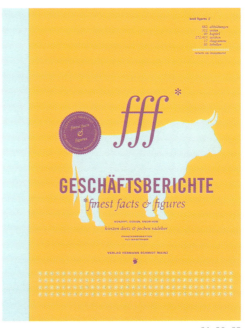

64 29 93

148 Color Harmony: Layout

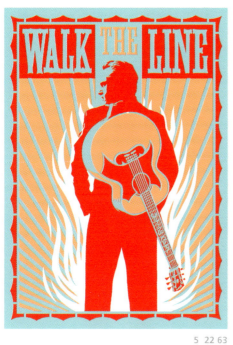
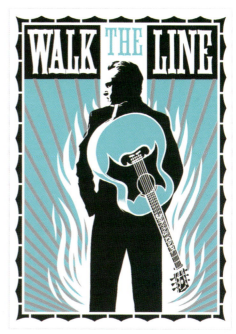

5 22 63

101 62 105

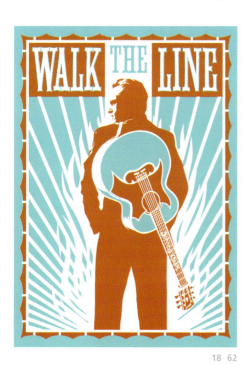
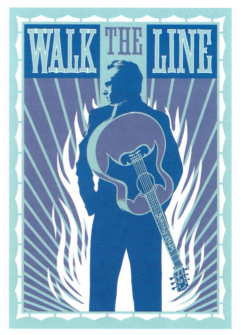

18 62

63 69 79

tropical

tropical

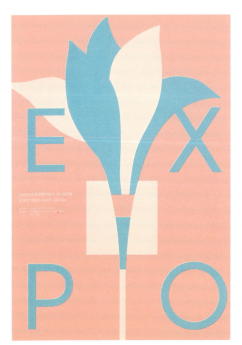

7 62 24

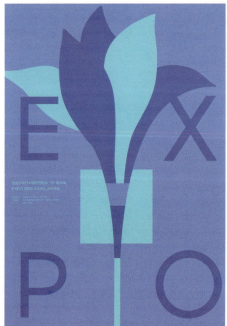

62 70 78

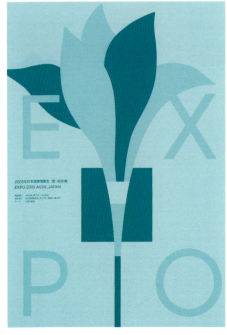

63 58 62

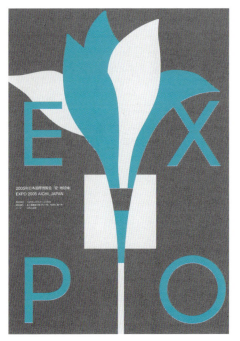

97 102 61

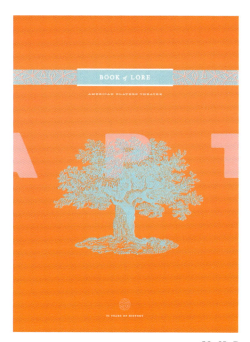

20 63 7

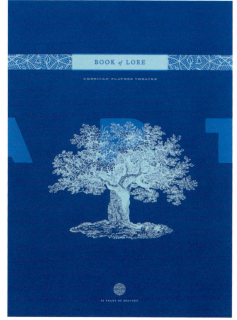

63 69 79

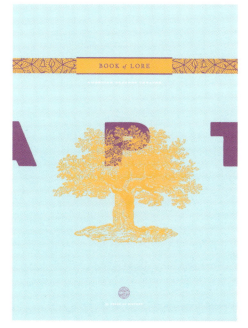

64 29 93

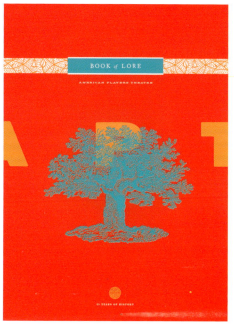

5 21 61

tropical

tropical

5 21 61

13 61

53 63 69

97 102 61

152 Color Harmony: Layout

tropical

53 63 69

63 32 96

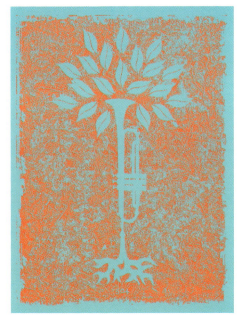

13 62

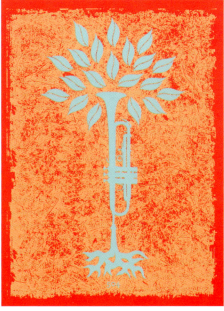

5 22 63

tropical

107 54 62 70

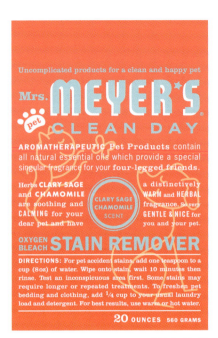
107 5 22 63

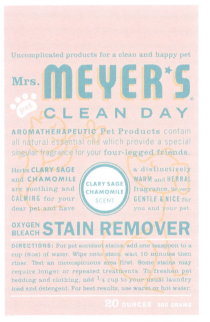
107 23 8 62

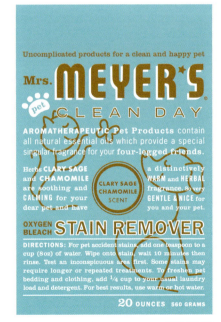
107 25 62

154 Color Harmony: Layout

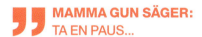 MAMMA GUN SÄGER: TA EN PAUS...

5 21 62

 MAMMA GUN SÄGER: TA EN PAUS...

45 55 62

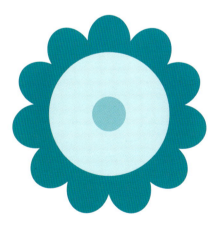

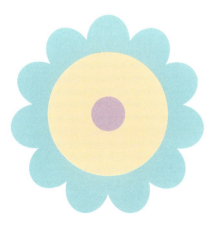

 MAMMA GUN SÄGER: TA EN PAUS...

59 64 62

 MAMMA GUN SÄGER: TA EN PAUS...

63 31 95

tropical

classic

Royal blue is the backbone of those colors deemed classic. As the name connotes, it is strong and trustworthy. Combined with its partners in the classic realm, it conveys strength and authority. The colors have a bold and accessible nature, as might be found with near-primary red, yellow, and blue combinations.

Strong hues of purple, blue, and green have soulfulness, like jazz, but when aligned with the somewhat monochromatic blue and gray combinations found in this palette, they convey a sense of stature and austere sophistication.

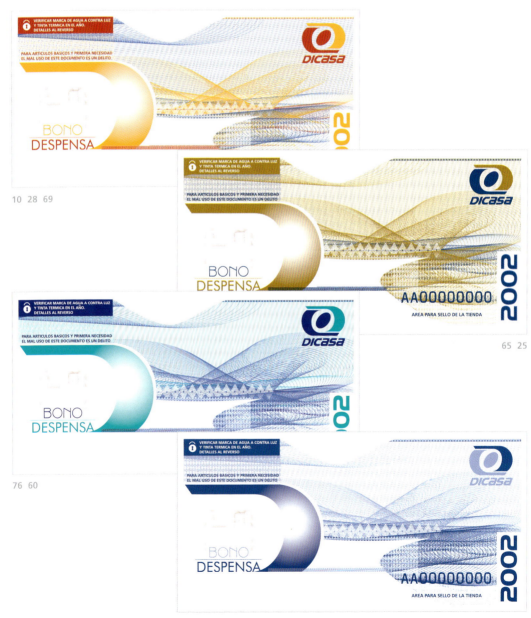

10 28 69

65 25

76 60

71 66

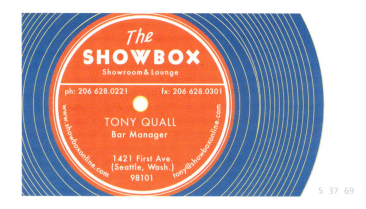
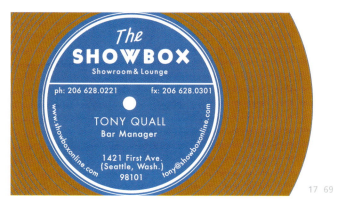
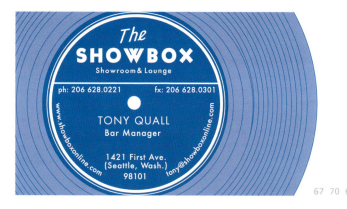
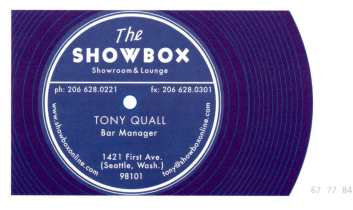

classic

classic

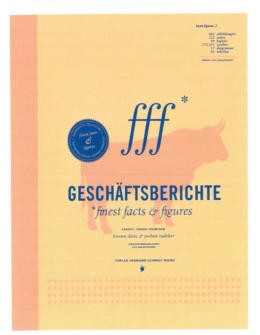

14 30 68

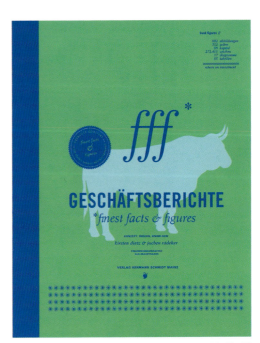

53 62 66

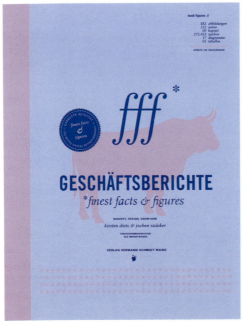

71 75 87

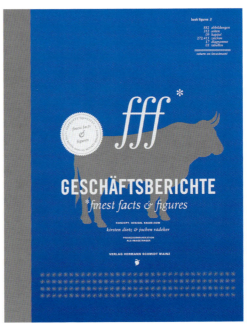

68 98 104

158 Color Harmony: Layout

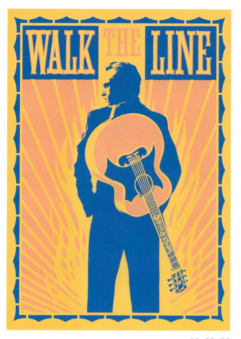

14 68 29

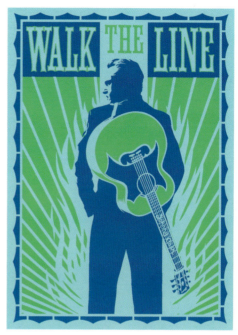

53 62 66

classic

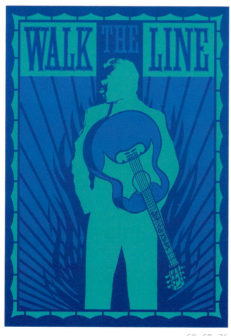

60 68 76

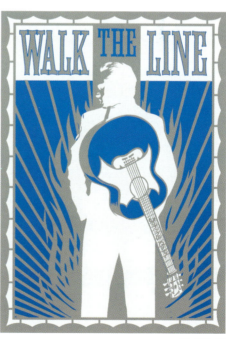

97 102 68

classic

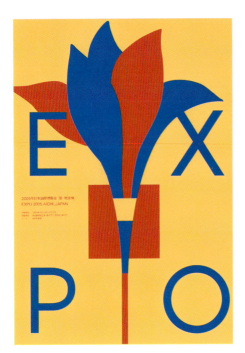
10 68 29

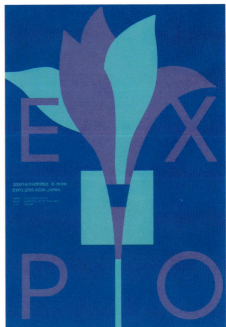
61 67 78

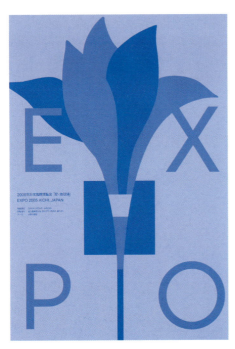
71 69 68

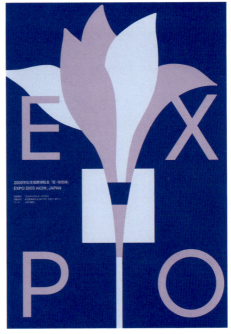
72 75 87

160 Color Harmony: Layout

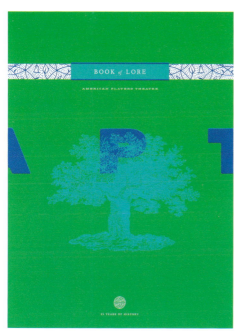

52 60 68

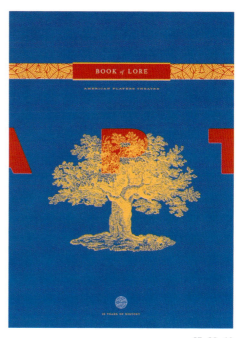

67 28 10

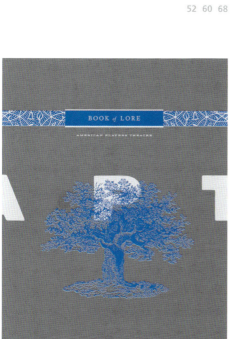

104 98 68

72 75 87

classic

classic

12 68 28

53 62 66

71 69 68

101 68 106

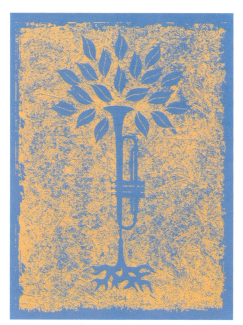

22 70

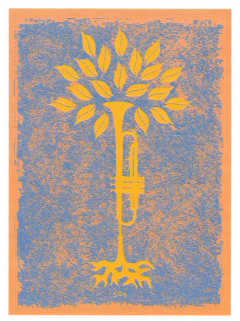

70 28 14

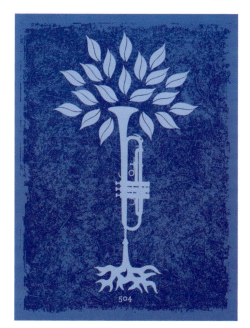

71 78 84

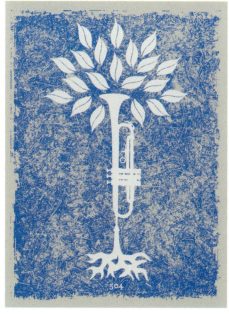

98 100 68

classic

classic

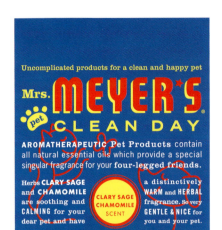

4 36 68

66 28 12

52 61 68

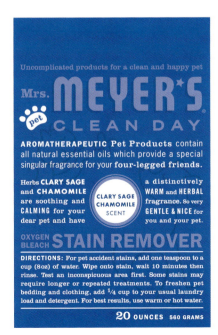

67 70 68

164 Color Harmony: Layout

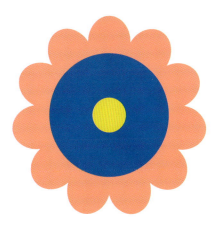

MAMMA GUN SÄGER:
TA EN PAUS...

6 35 68

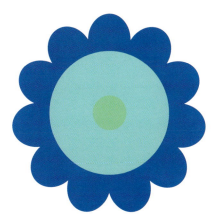

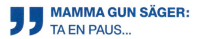
MAMMA GUN SÄGER:
TA EN PAUS...

54 62 68

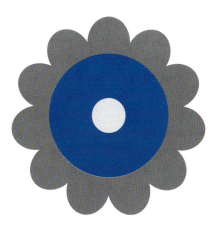

MAMMA GUN SÄGER:
TA EN PAUS...

68 98 104

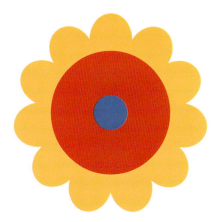

MAMMA GUN SÄGER:
TA EN PAUS...

69 29 11

calm

These are the colors we turn to when we need a place to rest our minds. Peacefulness pervades when we are surrounded by shades of blue; even the bright hues in this palette, the traditionally hot colors, can possess a sense of calming coolness. They emanate an ease reminiscent of the colors that appear when we open our eyes after napping on the beach, an ocean breeze all around.

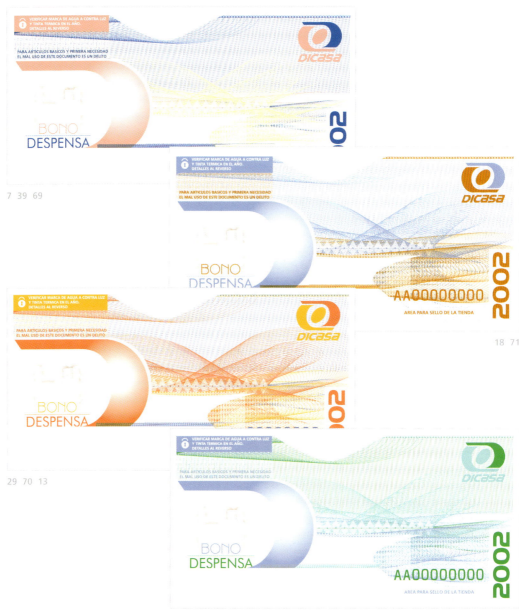

7 39 69

18 71

29 70 13

53 63 71

166 Color Harmony: Layout See Process Color Formulas on page 236 for CMYK values of colors shown

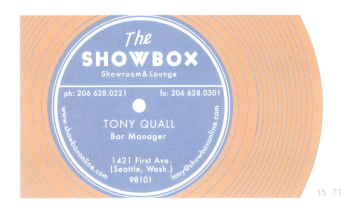

15 71

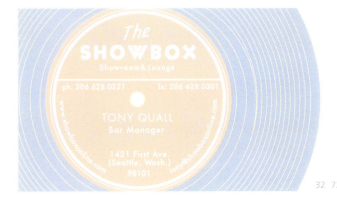

32 72 16

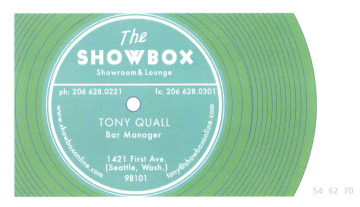

54 62 70

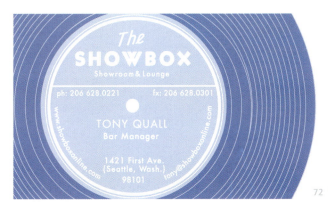

72 70

calm

167

calm

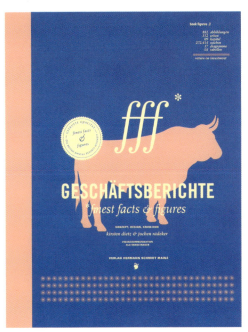

7 39 69

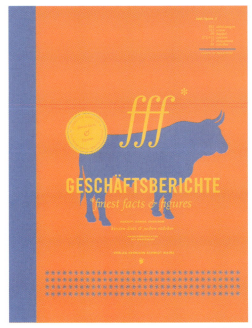

13 29 70

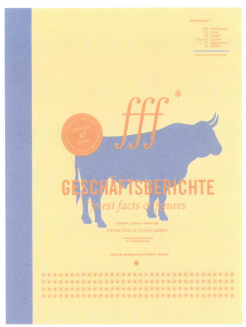

71 14 31

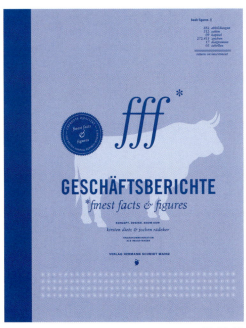

72 68 71

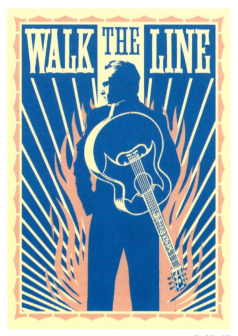

7 39 69

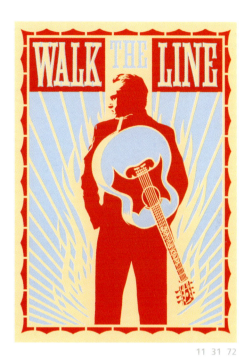

11 31 72

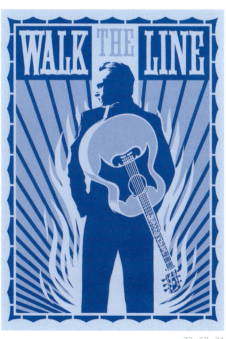

72 68 71

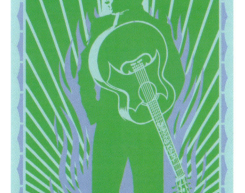

53 63 71

calm

calm

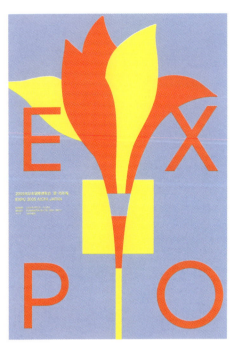

5 37 71

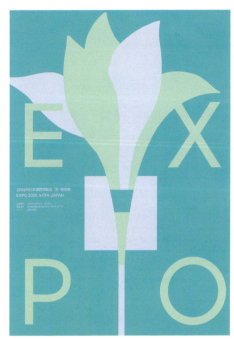

55 61 72

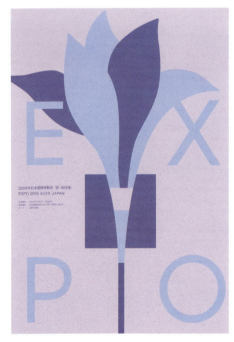

71 78 88

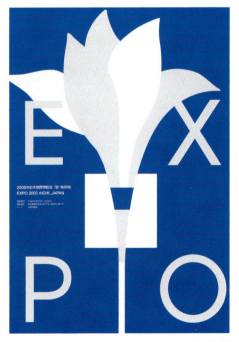

97 68 99

170 Color Harmony: Layout

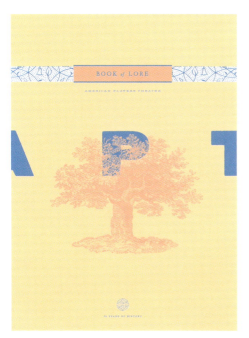
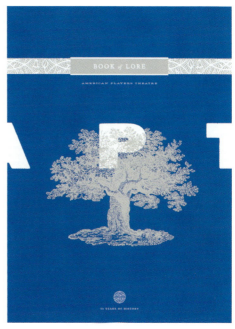
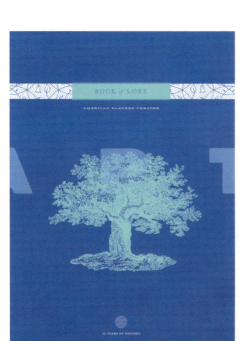
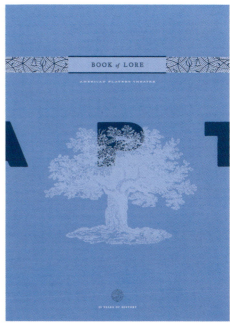

calm

31 70 15

100 67 97

62 70 78

71 65 70

171

calm

10 28 69

30 70 14

64 71 78

67 72 70

172 Color Harmony: Layout

calm

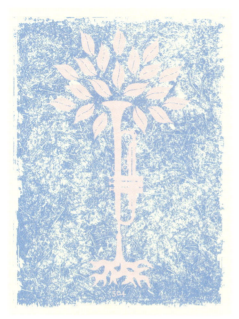

8 40 71

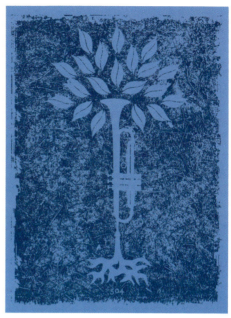

65 70

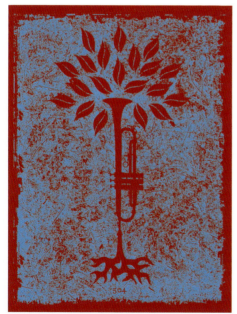

9 70

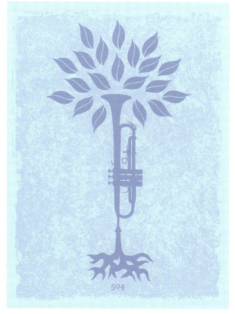

64 72 80

calm

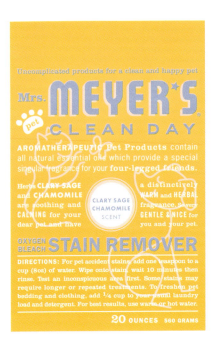
16 29 71

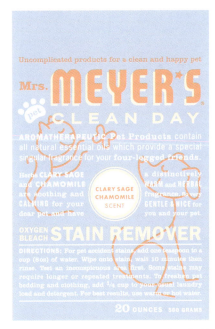
32 72 14

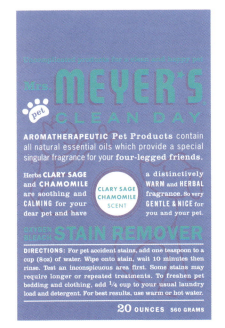
61 70 79

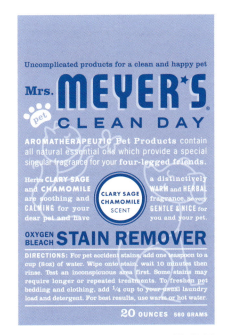
72 68 71

174 Color Harmony: Layout

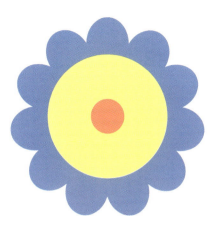

,, **MAMMA GUN SÄGER:**
TA EN PAUS...

6 38 70

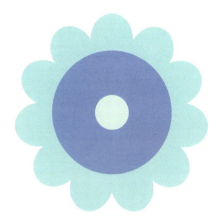

,, **MAMMA GUN SÄGER:**
TA EN PAUS...

56 63 70

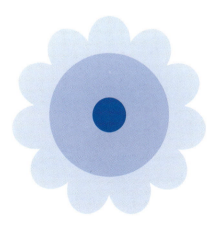

,, **MAMMA GUN SÄGER:**
TA EN PAUS...

72 68 71

,, **MAMMA GUN SÄGER:**
TA EN PAUS...

97 99 71

calm

regal

Powerful and deeply saturated, regal colors stand upon the strength of blue blended with the power of red. The deep purple we think of as royal helps define this group. When paired with its complement, yellow-orange, it makes a strong and visually arresting combination.

Eggplant hues, turquoise to yellow, red with yellow-greens—all these can denote the unusual and elegant. They are not for the halls of the everyday but for the courts of the proud—or those who would aspire to such claims.

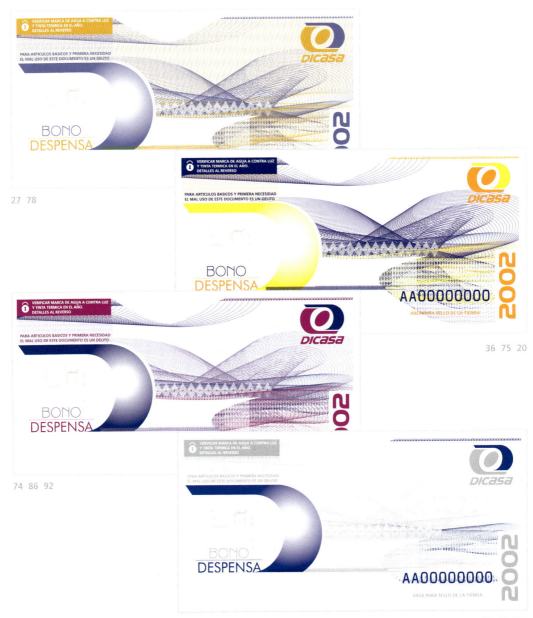

27 78

36 75 20

74 86 92

76 98 101

176 Color Harmony: Layout See Process Color Formulas on page 236 for CMYK values of colors shown

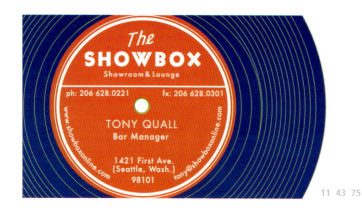

11 43 75

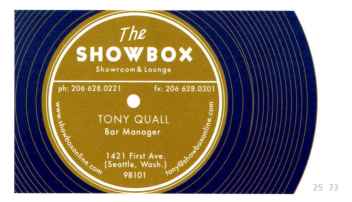

25 73

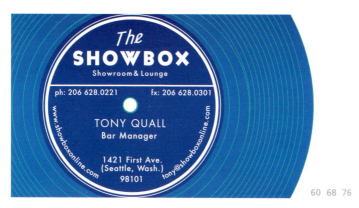

60 68 76

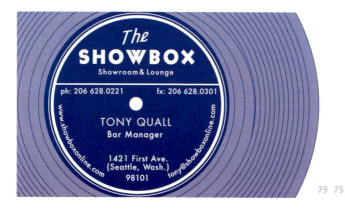

79 75

regal

regal

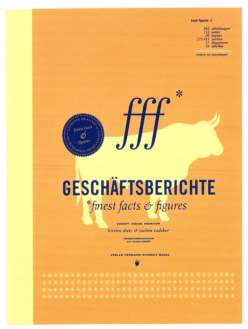

21 38 76

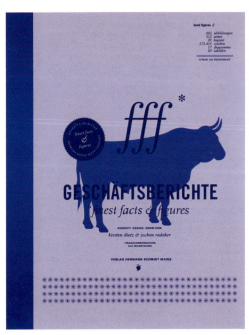

73 80 76

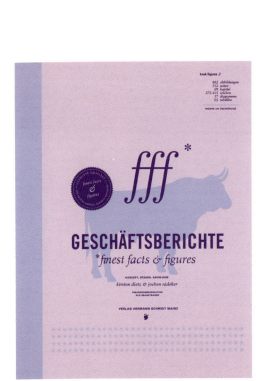

80 82 95

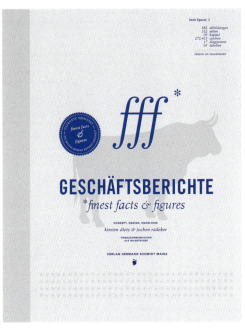

98 100 76

178 Color Harmony: Layout

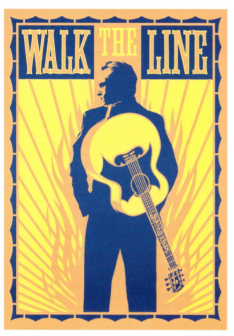

37 76 22

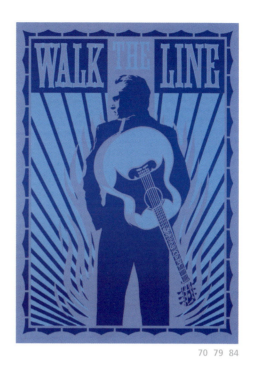

70 79 84

regal

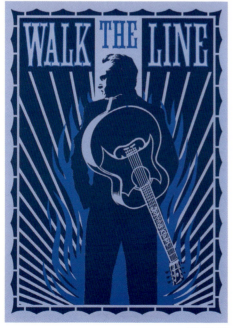

73 80 76

98 100 76

regal

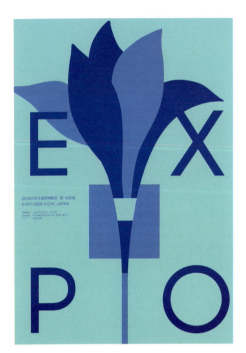

62 69 76

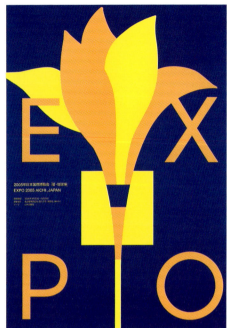

74 36 21

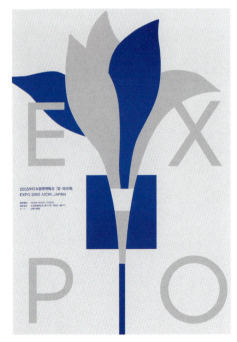

76 98 101

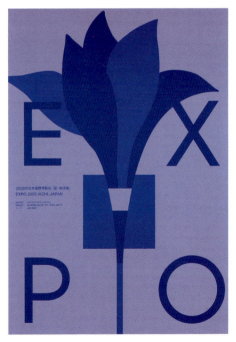

79 75 76

180 Color Harmony: Layout

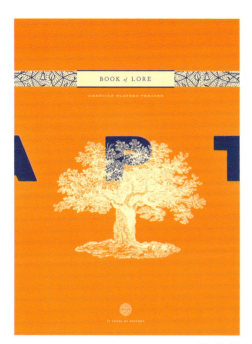

39 74 20

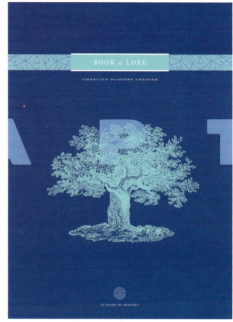

62 70 75

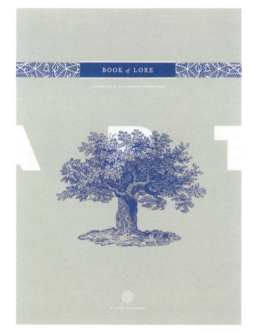

99 21 97

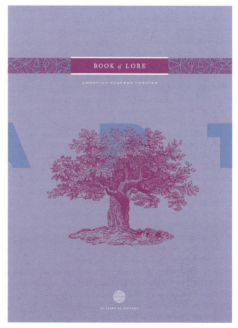

79 87 92

regal

regal

12 45 78

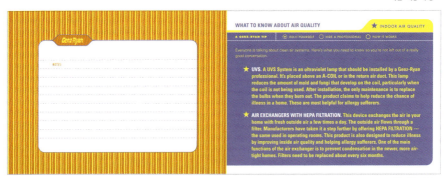

19 36 78

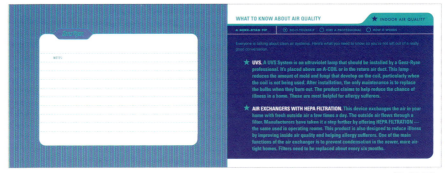

60 69 76

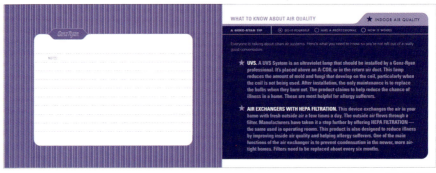

77 73 79

regal

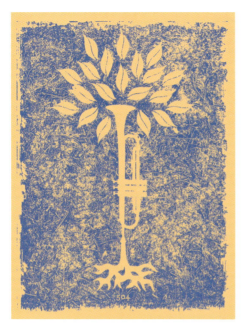

30 78

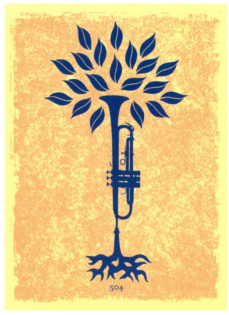

22 38 76

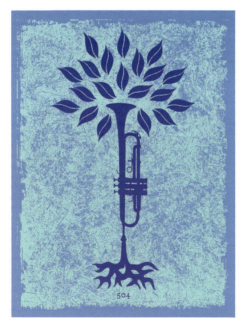

62 69 76

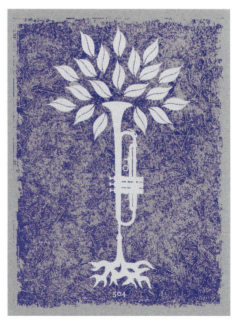

101 98 76

regal

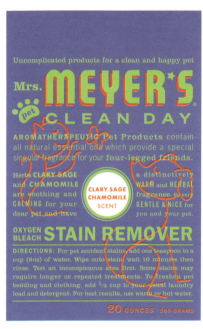

12 45 78

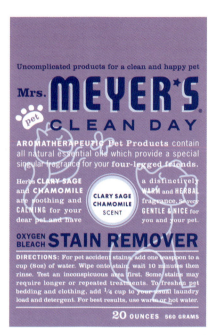

72 74 86

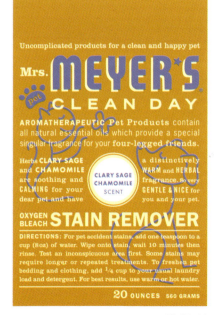

78 39 19

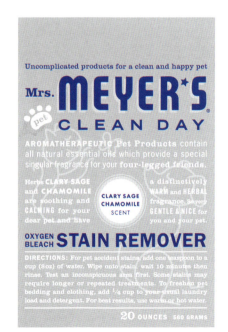

98 100 76

184 Color Harmony: Layout

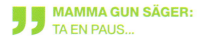
MAMMA GUN SÄGER:
TA EN PAUS...

12 44 76

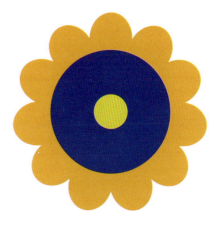

MAMMA GUN SÄGER:
TA EN PAUS...

19 34 75

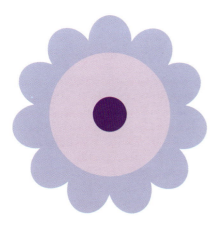

MAMMA GUN SÄGER:
TA EN PAUS...

80 82 95

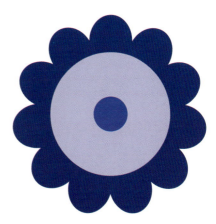

MAMMA GUN SÄGER:
TA EN PAUS...

73 80 76

energetic

Even by themselves—and especially when combined with their complements—these colors vibrate. They have electricity, and their loud personalities demand attention.

These largely tertiary colors have an undeniable boldness. Bright, joyful, even insouciant, they define people, places, and events that embody celebration, grandness of scale, or just the everyday. They cannot be contained and they live life out loud—every moment of it.

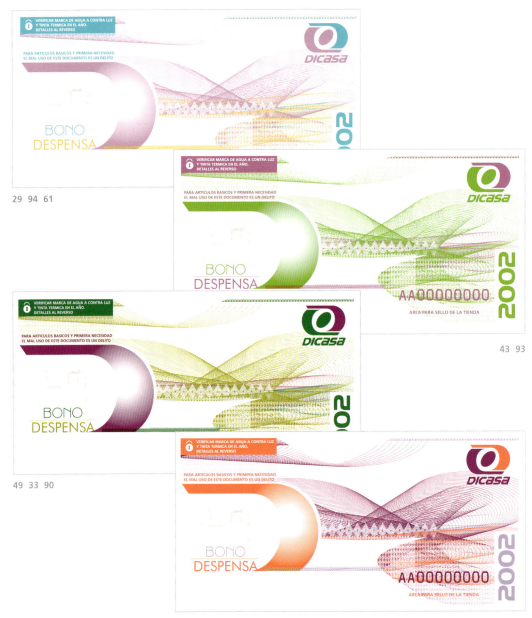

29 94 61

43 93

49 33 90

87 90 5

186 Color Harmony: Layout See Process Color Formulas on page 236 for CMYK values of colors shown

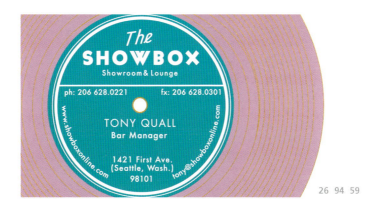

26 94 59

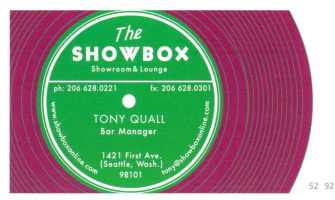

52 92

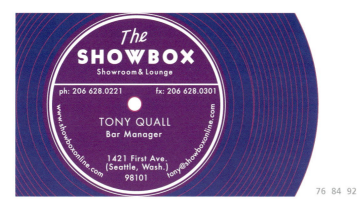

76 84 92

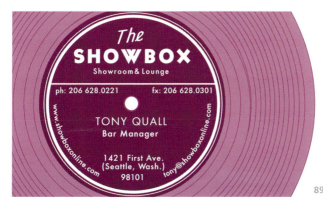

89 91 93

energetic

energetic

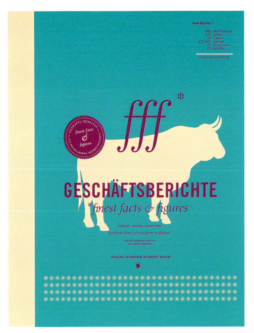

31 91 60

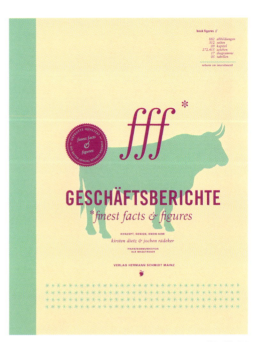

31 92 54

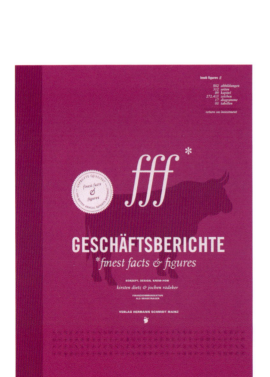

90 96 92

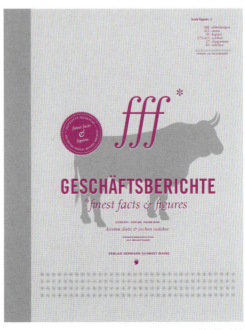

99 92 102

Color Harmony: Layout

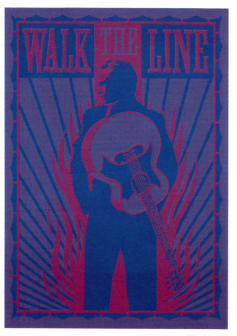
76 85 92

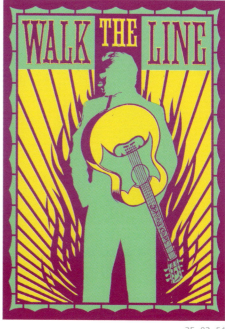
35 92 54

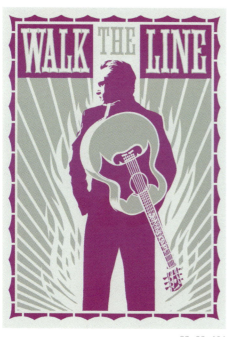
92 98 101

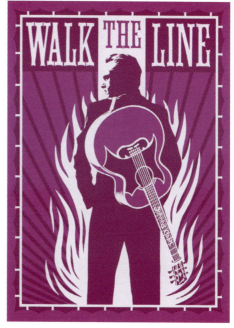
96 90 92

energetic

energetic

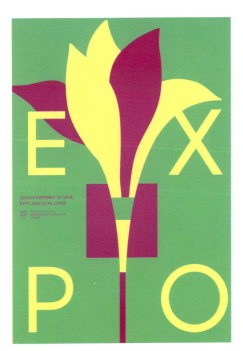
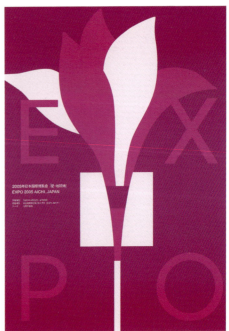

53 37 92

90 96 92

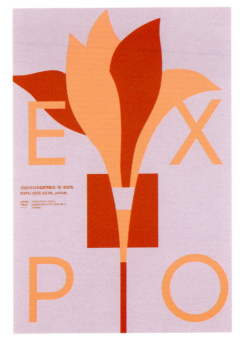
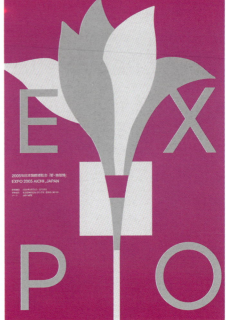

95 2 13

99 92 102

190 Color Harmony: Layout

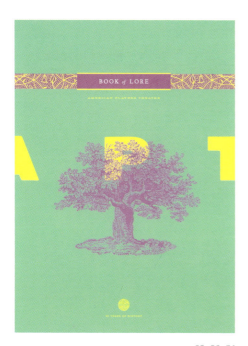

93 36 54

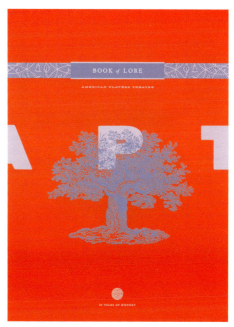

86 95 4

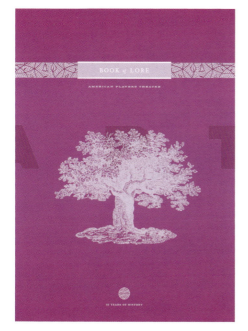

91 95 92

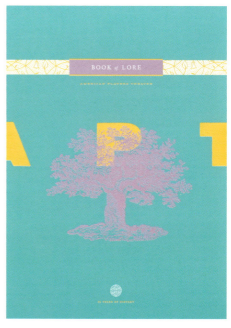

94 61 29

energetic

energetic

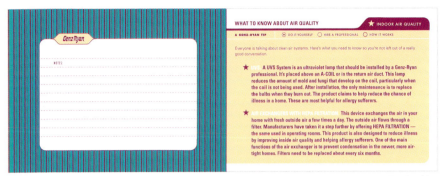

31 91 60

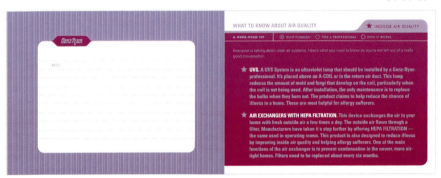

79 87 91

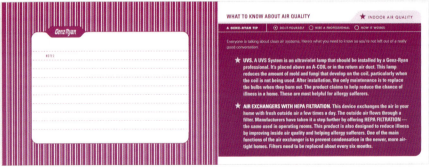

90 96 92

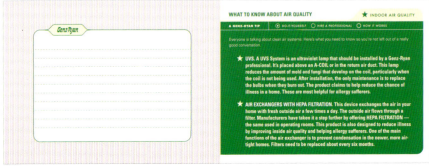

96 40 50

192 Color Harmony: Layout

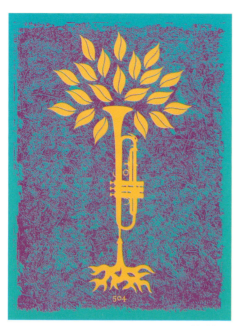

28 92 60

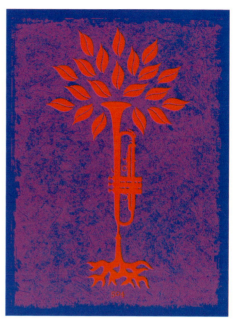

84 92 4

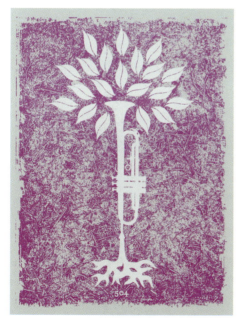

99 98 92

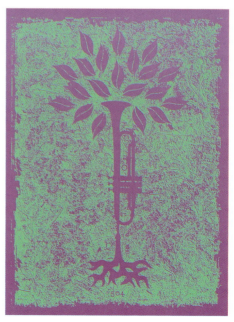

54 93

energetic

energetic

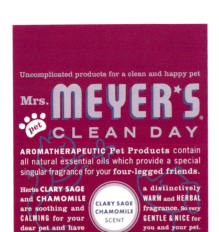
78 88 92

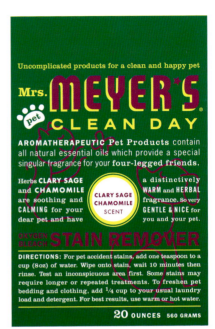
90 36 49

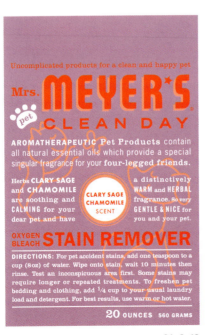
94 6 12

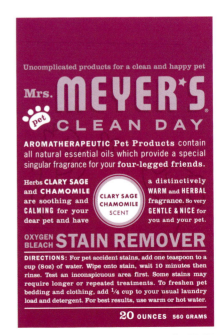
91 95 92

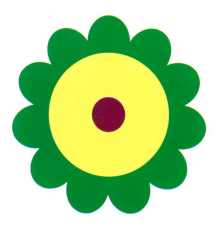

MAMMA GUN SÄGER:
TA EN PAUS…

37 90 52

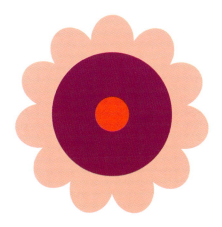

MAMMA GUN SÄGER:
TA EN PAUS…

91 7 12

energetic

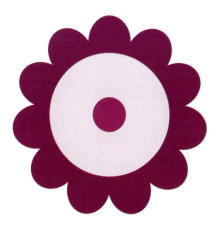

MAMMA GUN SÄGER:
TA EN PAUS…

96 90 92

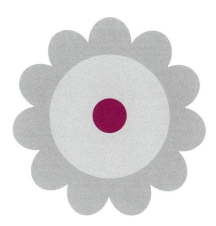

MAMMA GUN SÄGER:
TA EN PAUS…

98 100 92

subdued

As the adjective tells us, these hues do not contain the brashness of the energetic colors but instead are a step down in brightness—even a bit grayed. They lack the contrast of the energetic colors and, as a result, elicit a sense of restfulness.

But subdued colors are not completely dour: they spring back to life when paired with a complement or a more vivid tone of the original hue. Though they do not demand attention, they are by no means mundane. Like those who possess confidence through hard-earned experience, who have learned and enjoy the virtue of patience, the subdued colors know their limits and herald their strengths.

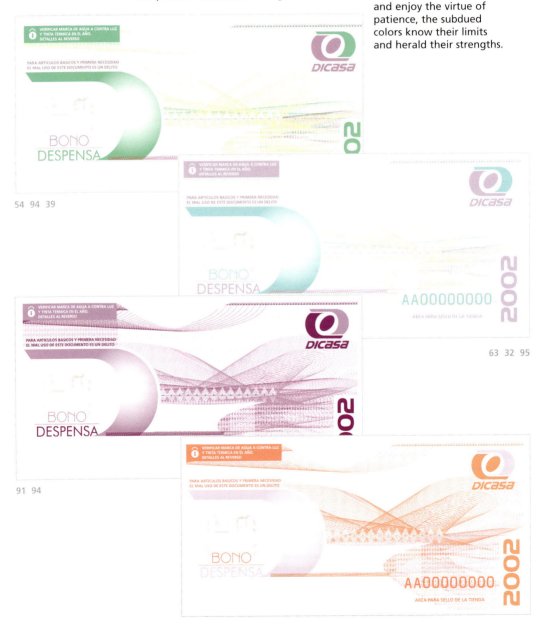

54 94 39

63 32 95

91 94

14 96 6

196 Color Harmony: Layout See Process Color Formulas on page 236 for CMYK values of colors shown

48 96

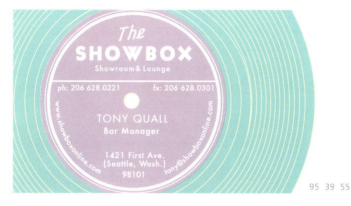

95 39 55

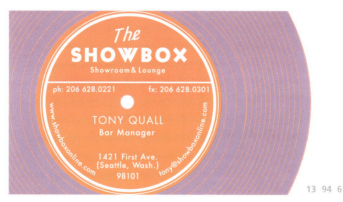

13 94 6

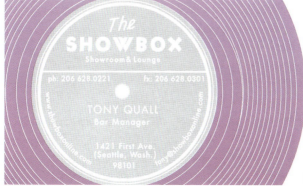

99 94 98

subdued

subdued

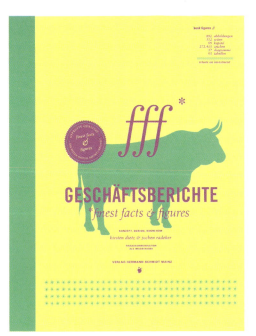

54 93 38

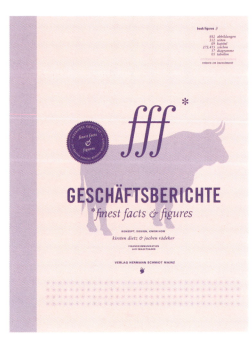

85 95 8

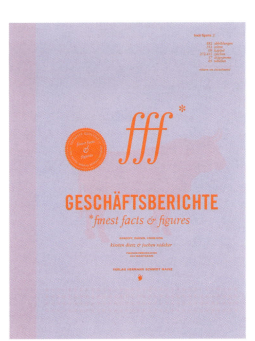

88 95 5

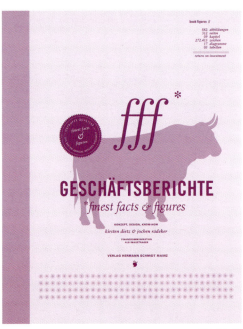

90 96 94

198 Color Harmony: Layout

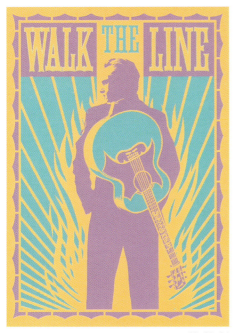

62 30 94

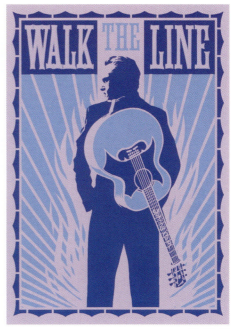

80 85 95

subdued

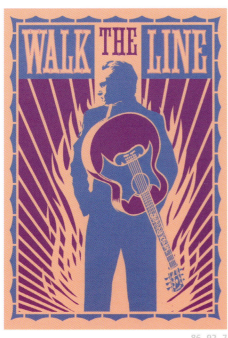

86 92 7

96 95 94

subdued

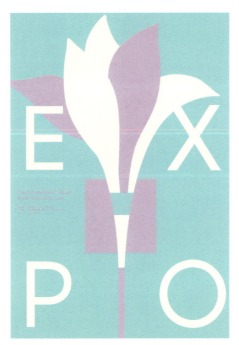

55 40 95

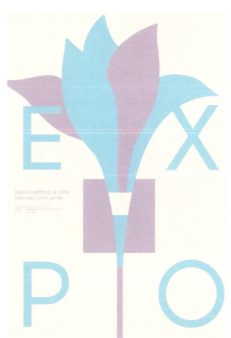

32 63 95

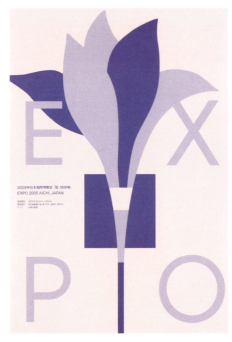

85 95 8

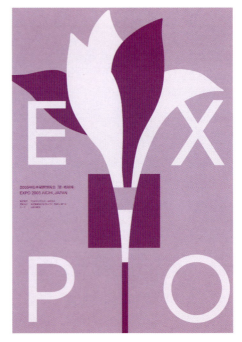

90 96 94

subdued

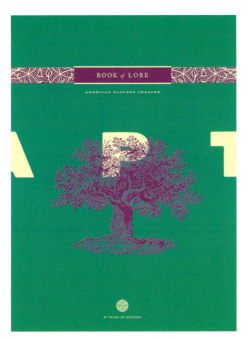

51 91 38

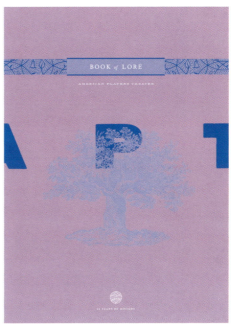

77 87 94

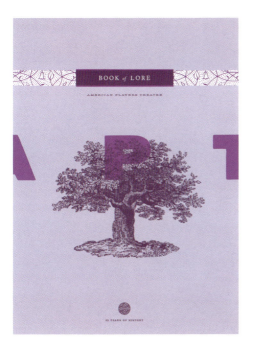

89 92 95

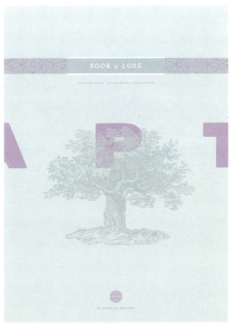

100 94 98

subdued

54 93 38

62 30 94

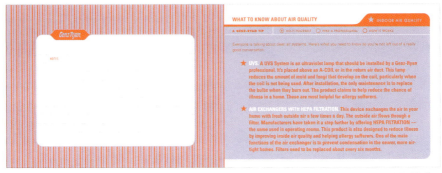

88 95 5

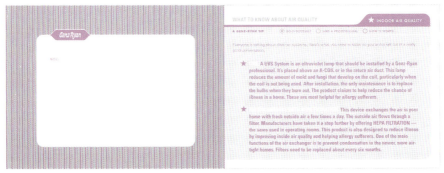

94 98 101

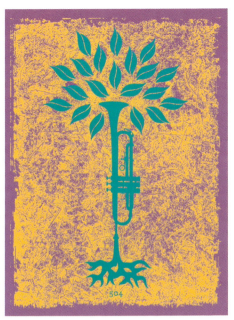

29 60 93

40 96

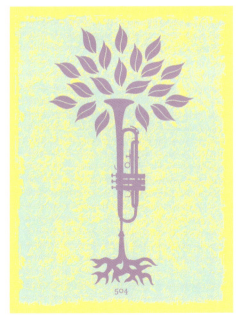

56 94 38

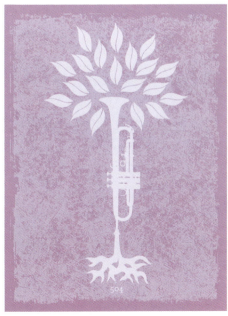

96 95 94

subdued

subdued

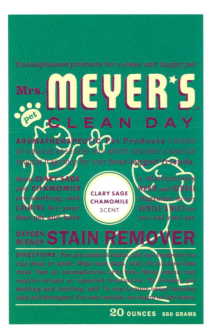

51 91 38

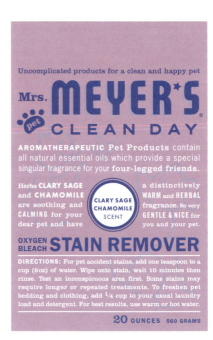

77 87 94

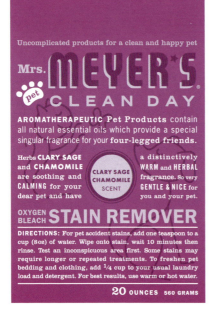

89 92 95

100 94 98

204 Color Harmony: Layout

MAMMA GUN SÄGER:
TA EN PAUS...

26 59 94

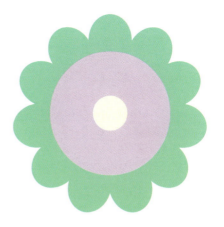

MAMMA GUN SÄGER:
TA EN PAUS...

54 95 40

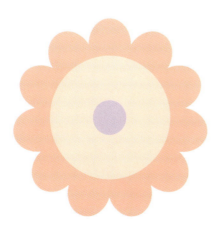

MAMMA GUN SÄGER:
TA EN PAUS...

95 7 16

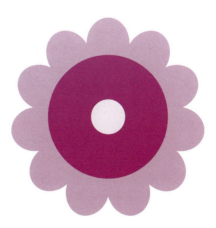

MAMMA GUN SÄGER:
TA EN PAUS...

96 92 94

subdued

professional

In the professional world, there is an emphasis is on being clear, truthful, and to the point. This no-frills, no-nonsense mindset often brings a humorless rather than spirited approach. Color-wise, this approach translates to grays and tonal blacks. But the professional colors are not simply grays; reds, oranges, yellows, greens, teals, blues, purples, and even magentas also play a role in this palette, playing off of the backbone of blacks and grays. That being said, the dominant color is never surpassed or overpowered. To do otherwise would be, well, unprofessional.

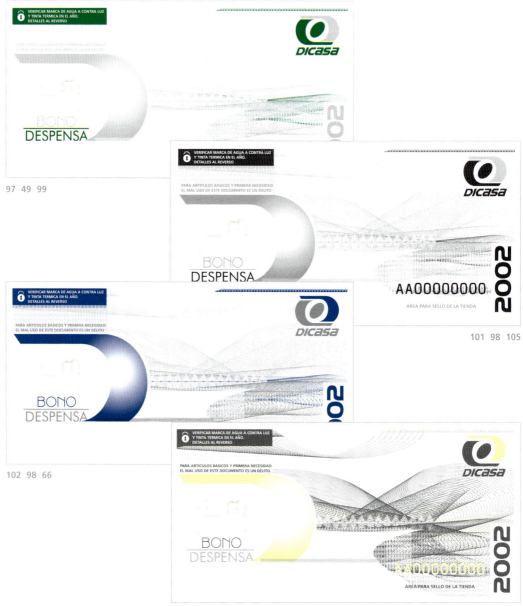

97 49 99

101 98 105

102 98 66

104 100 39

See Process Color Formulas on page 236 for CMYK values of colors shown

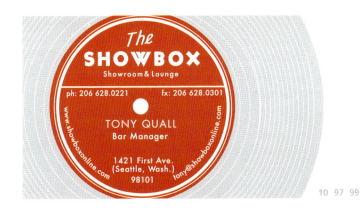

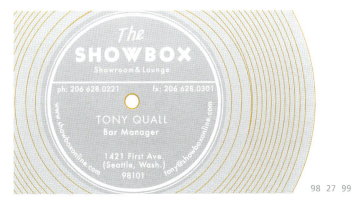

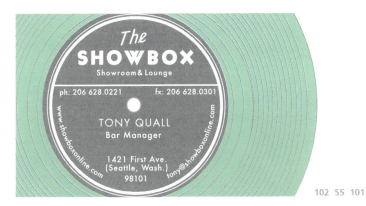

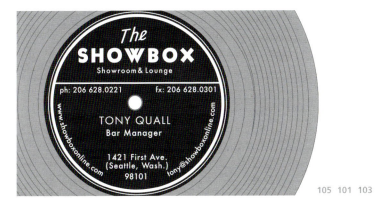

professional

professional

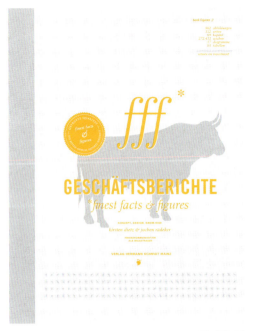

97 100 28

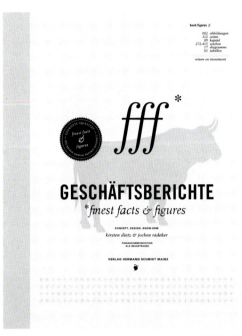

99 97 106

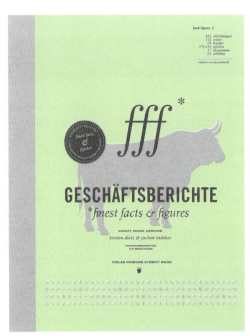

100 47 104

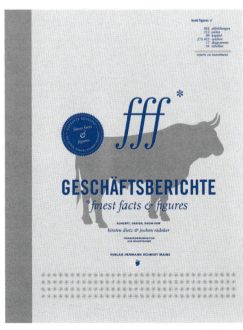

102 98 66

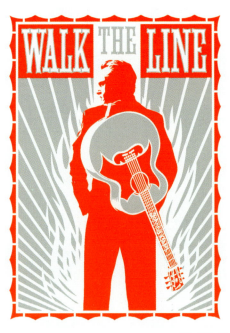

12 100 97 97 42 98

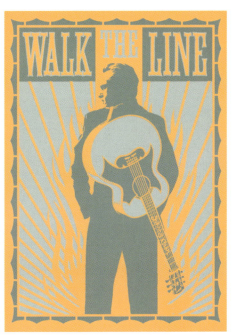

101 98 105 99 102 22

professional

209

professional

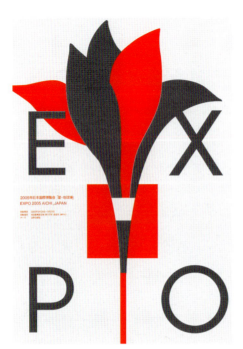
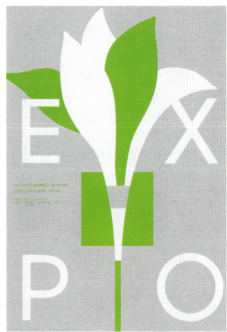

97 4 104

97 44 99

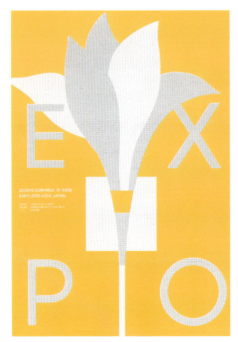
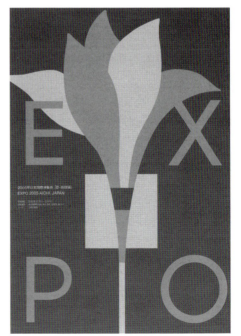

98 29 97

104 100 102

210 Color Harmony: Layout

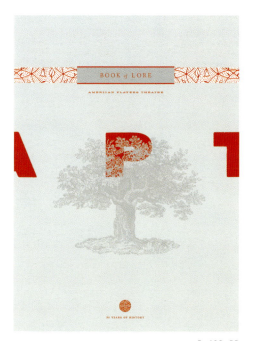

3 100 98

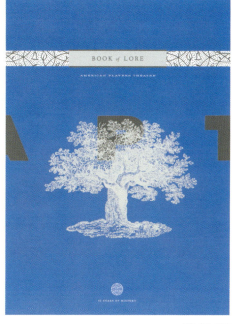

70 98 103

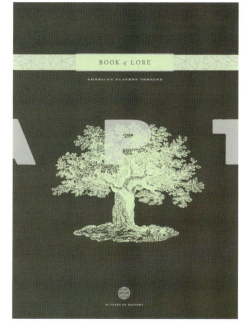

100 47 104

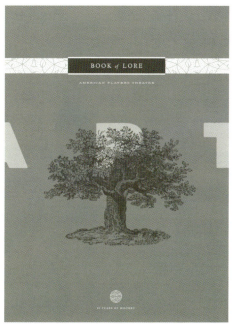

99 104 102

professional

professional

212 Color Harmony: Layout

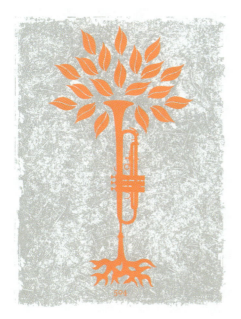

97 14 99

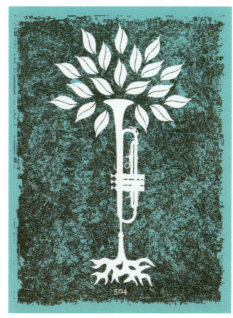

97 62 104

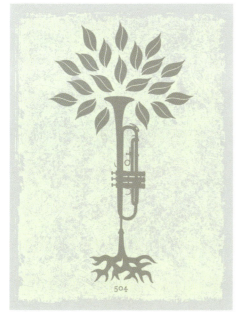

101 98 48

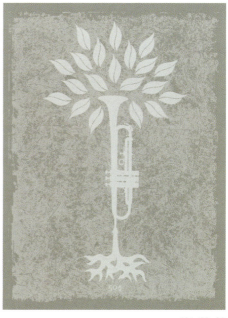

101 99 98

professional

professional

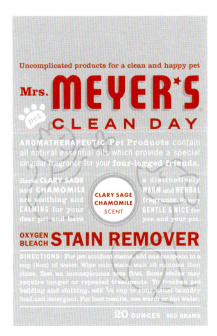

3 100 98

98 70 103

99 104 102

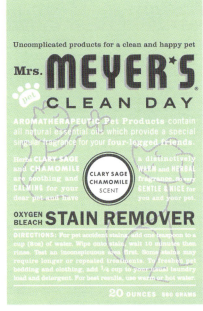

100 47 104

„ MAMMA GUN SÄGER:
TA EN PAUS...

97 2 98

„ MAMMA GUN SÄGER:
TA EN PAUS...

98 100 101

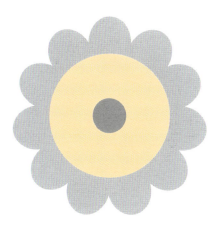

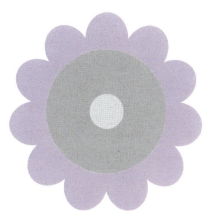

„ MAMMA GUN SÄGER:
TA EN PAUS...

100 31 102

„ MAMMA GUN SÄGER:
TA EN PAUS...

101 88 98

professional

pure

White is not the absence of color but the presence of all color. It is often thought of as plain, nothingness, vanilla. But vanilla's association with plainness is undeserved: smell vanilla and you are taken away. It's rich and beautiful, like white.

White is clean. White is good. White is without blame. White is tranquil. White is refined. Combined with soft hues and colors, white builds personalities. It is a blank slate that holds the power to magnify whatever is paired with it. That is why purity is so powerful.

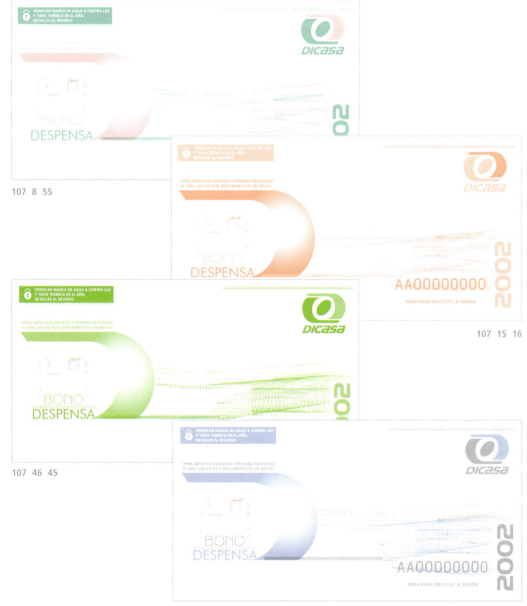

107 8 55

107 15 16

107 46 45

107 72 100

See Process Color Formulas on page 236 for CMYK values of colors shown

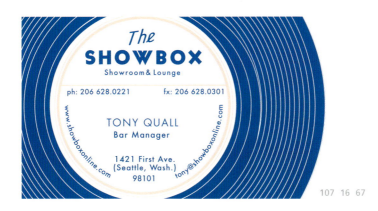

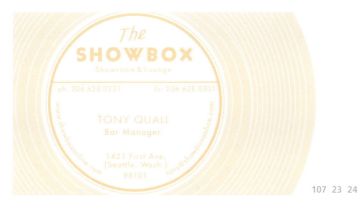

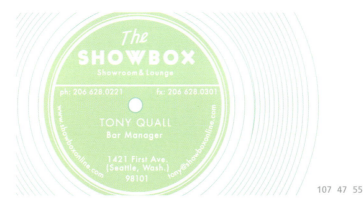

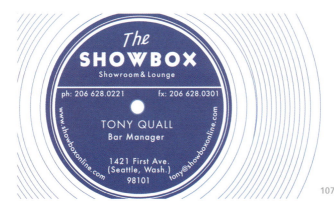

pure

pure

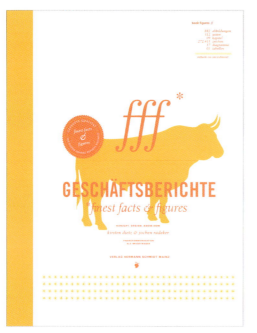

107 13 29

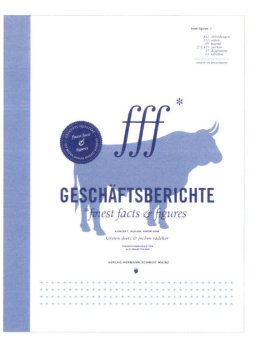

107 71 78

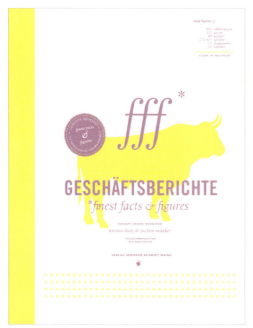

107 37 94

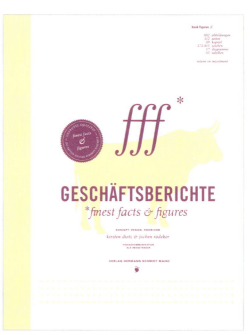

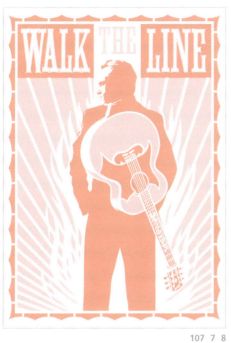
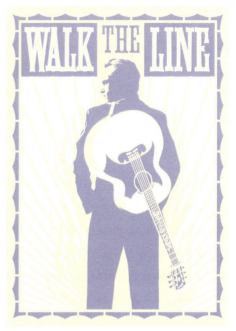

pure

107 7 8

107 40 88

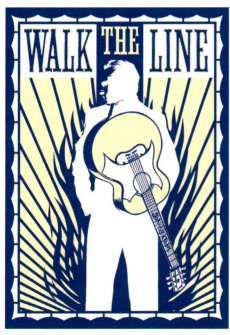
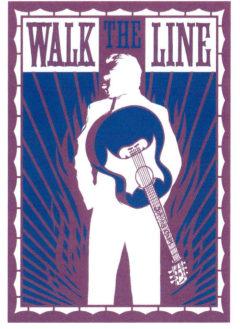

107 75 39

107 78 93

pure

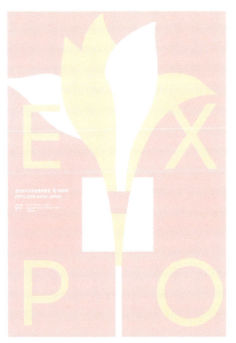

107 8 32

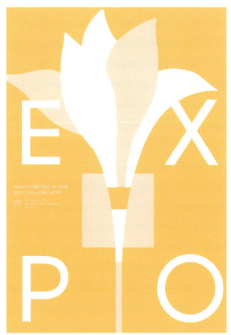

107 24 30

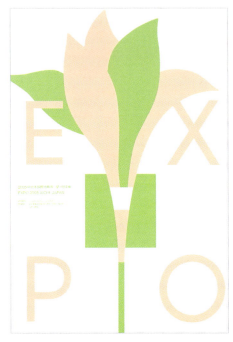

107 24 46

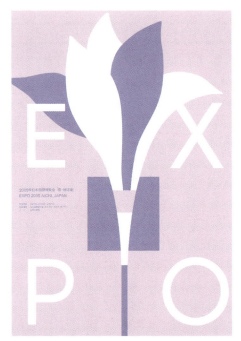

107 80 96

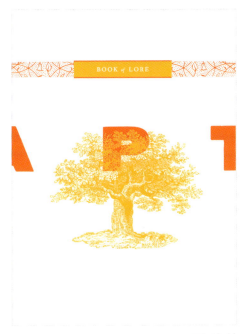

107 13 29

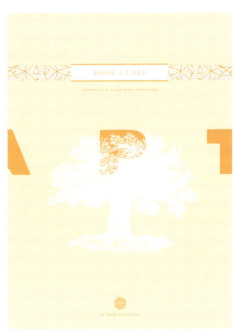

pure

107 22 32

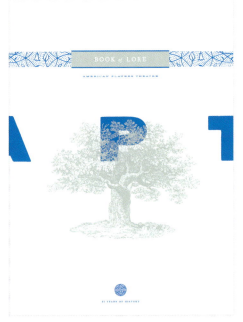

107 68 99

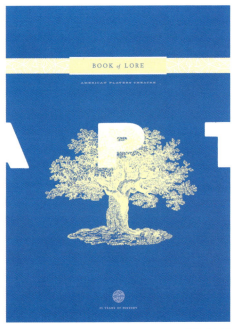

107 78 39

pure

107 13 29

107 32 80

107 39 93

107 100 67

pure

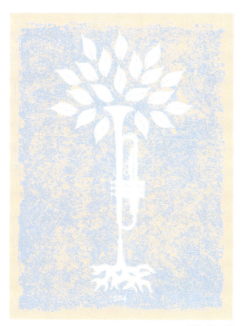

107 24 72

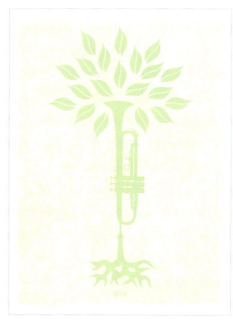

107 40 47

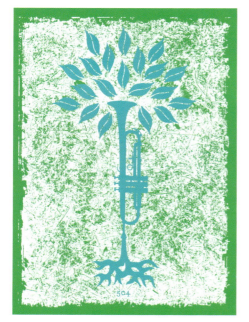

107 61 53

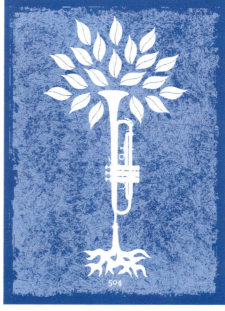

107 71 78

pure

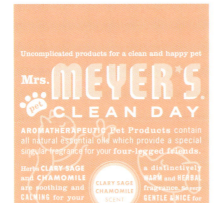

107 15 16

107 38 54

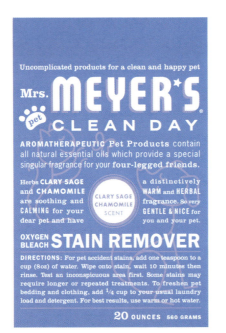

107 70 80

107 96 48

224 Color Harmony: Layout

pure

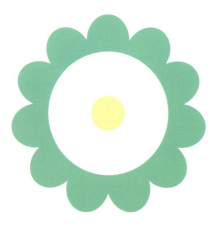

107 38 54

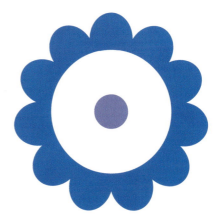

107 69 79

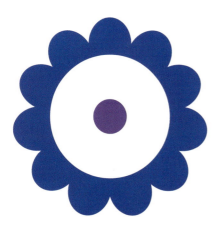

107 77 85

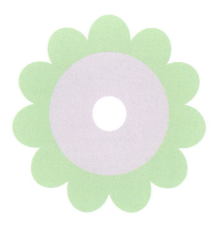

107 96 47

graphic

No color commands respect like black. It is outwardly simple yet silently complex—a still river running deep. Nothing beats the appeal of the little black dress. And what can capture your attention as quickly as a splash of color across a velvety black field?

Black is the strong, silent type. For all its presence and mystery, it requires few words. It allows the other colors to do all the talking, while quietly grounding them in sophistication. From elegant to playful, graphic colors convey strength and conviction.

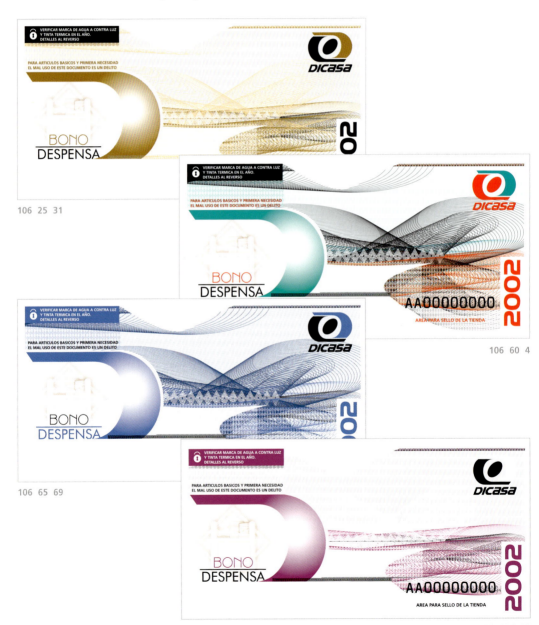

106 25 31

106 60 4

106 65 69

106 107 92

226 Color Harmony: Layout See Process Color Formulas on page 236 for CMYK values of colors shown

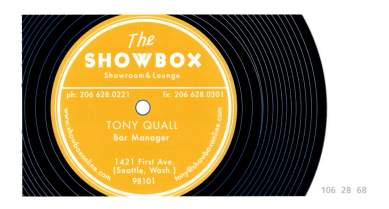
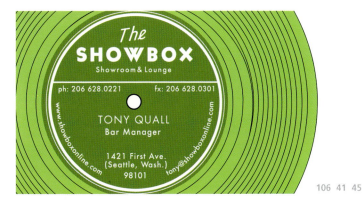
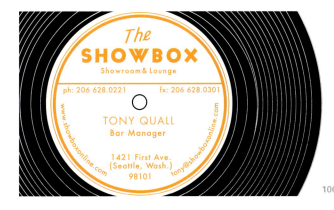

graphic

graphic

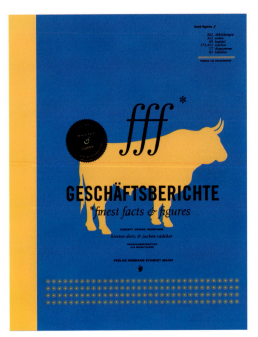

106 28 68

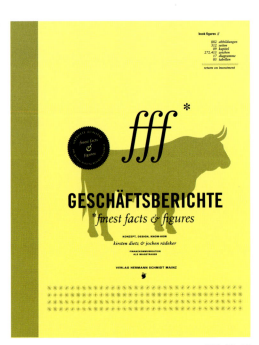

106 33 37

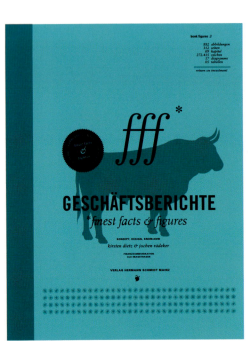

106 57 61

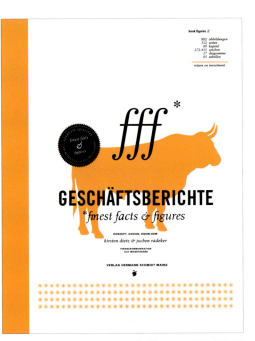

106 107 20

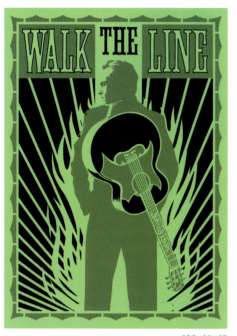
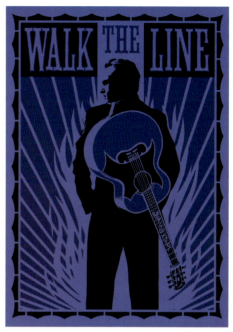

graphic

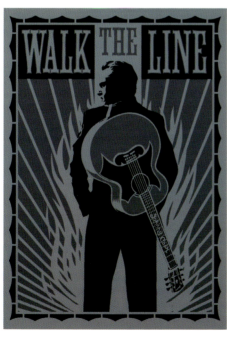
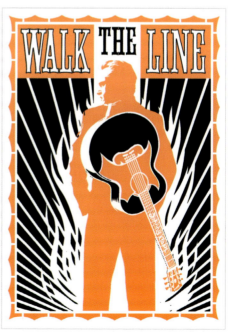

graphic

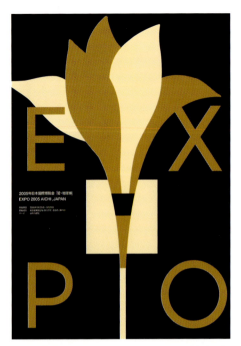
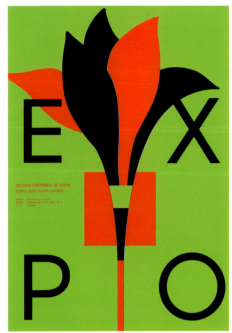

106 25 31
106 44 4

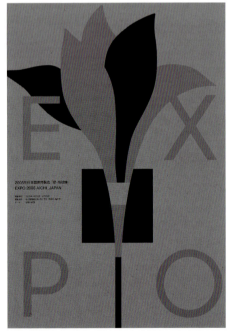
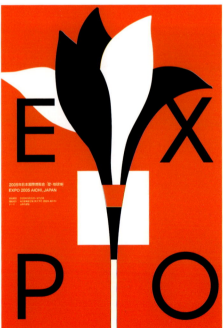

106 103 104
106 107 4

graphic

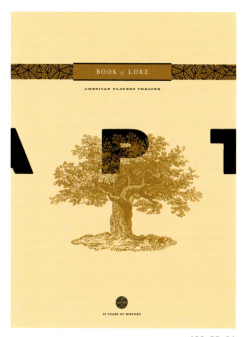

106 25 31

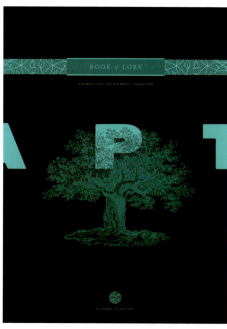

106 57 61

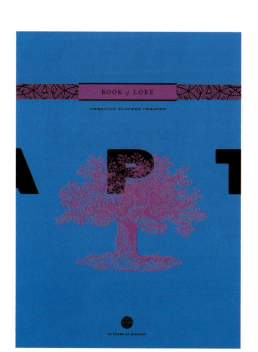

106 68 92

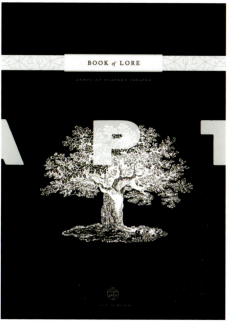

106 107 98

graphic

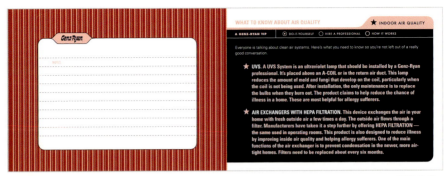

106 1 7

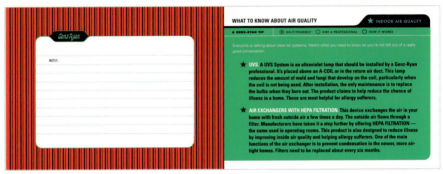

10 6 4 52

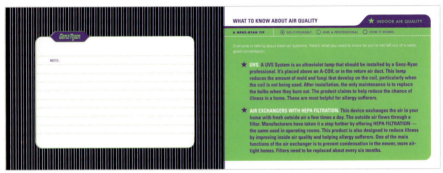

106 44 84

106 57 61

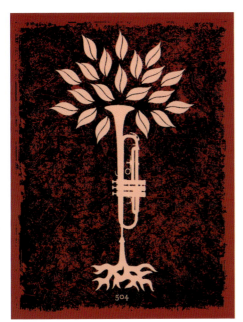

106 9 15

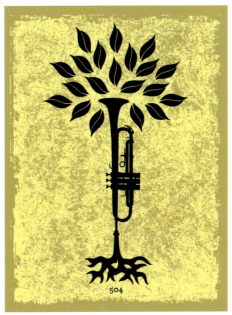

106 33 37

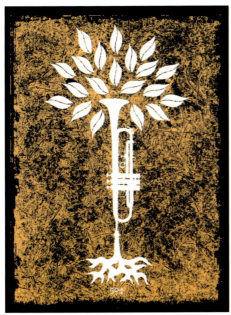

106 107 28

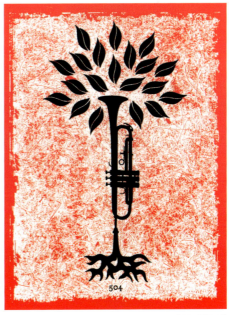

106 107 12

graphic

graphic

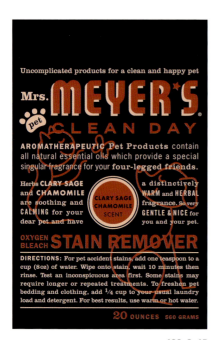

106 9 15

106 12 68

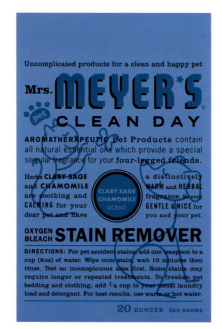

106 65 69

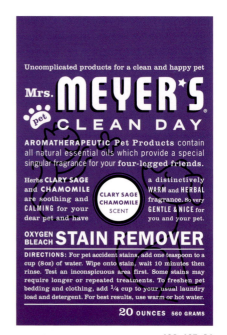

106 107 84

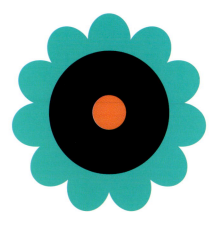

MAMMA GUN SÄGER:
TA EN PAUS...

106 12 60

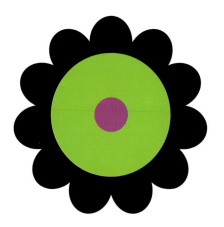

MAMMA GUN SÄGER:
TA EN PAUS...

106 44 92

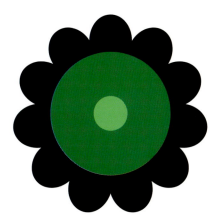

MAMMA GUN SÄGER:
TA EN PAUS...

10 6 49 53

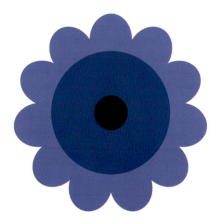

MAMMA GUN SÄGER:
TA EN PAUS...

106 73 77

graphic

process color formulas

color number		C	M	Y	K
1		0	100	100	45
2		0	100	100	25
3		0	100	100	15
4		0	100	100	0
5		0	85	70	0
6		0	65	50	0

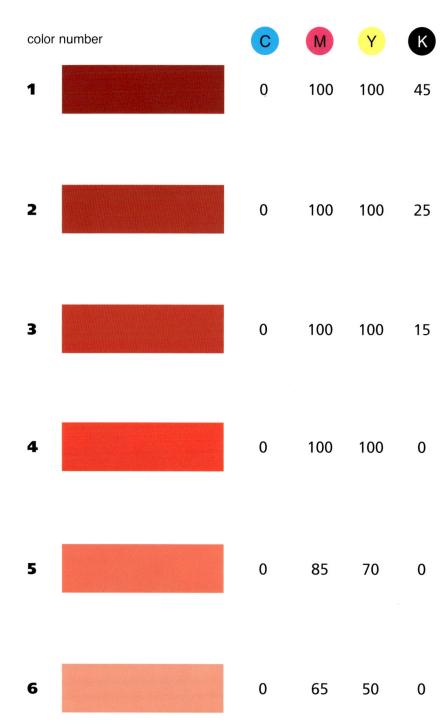

color number		C	M	Y	K
7		0	45	30	0
8		0	20	10	0
9		0	90	80	45
10		0	90	80	25
11		0	90	80	15
12		0	90	80	0

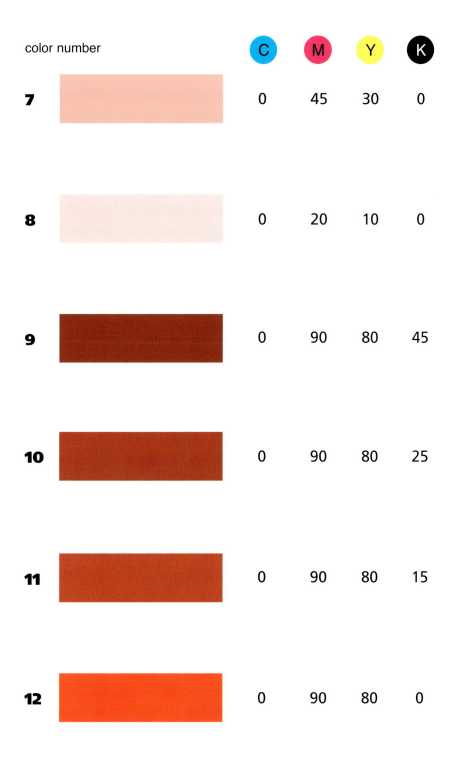

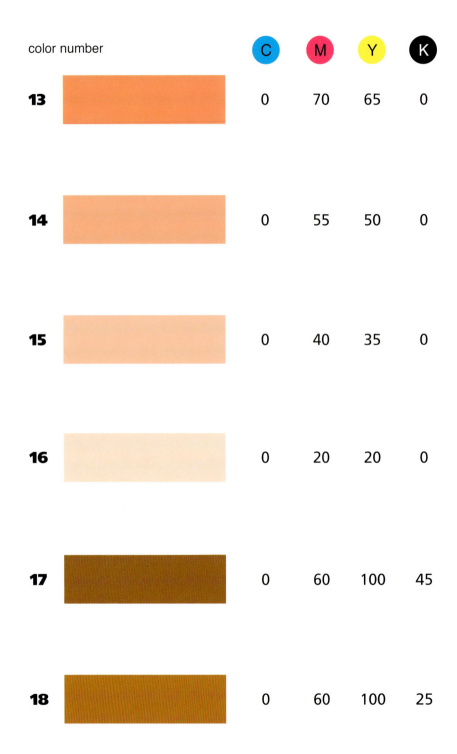

color number		C	M	Y	K
19	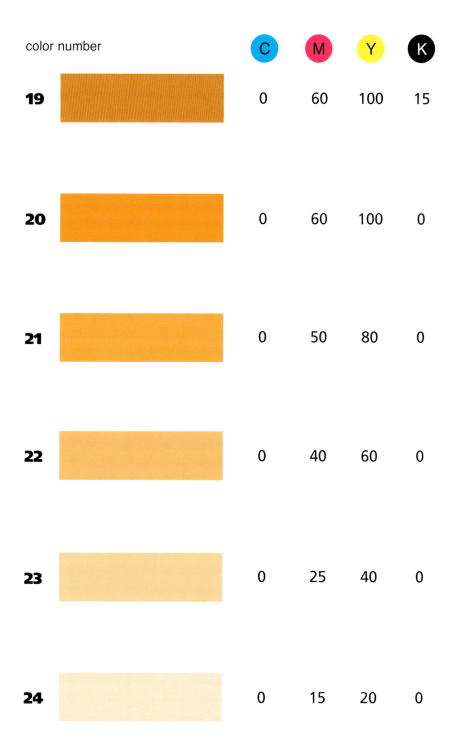	0	60	100	15
20		0	60	100	0
21		0	50	80	0
22		0	40	60	0
23		0	25	40	0
24		0	15	20	0

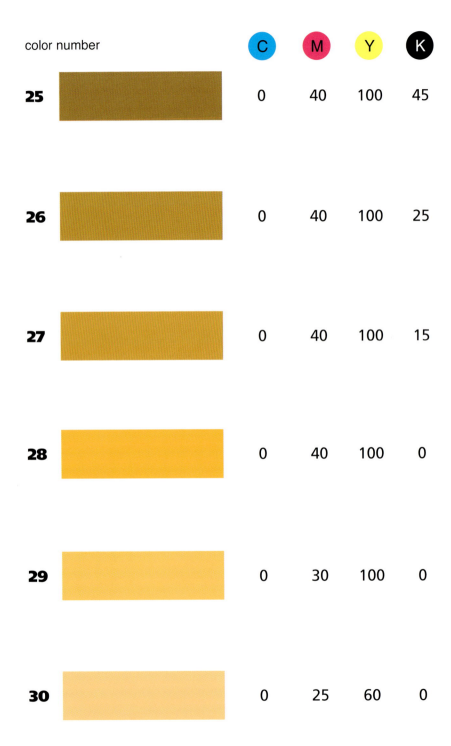

color number	C	M	Y	K
31	0	15	40	0
32	0	10	20	0
33	0	0	100	45
34	0	0	100	25
35	0	0	100	15
36	0	0	100	0

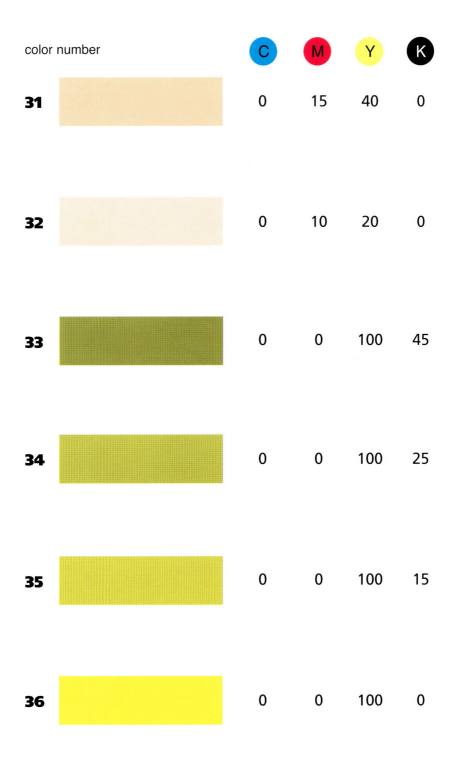

color number	C	M	Y	K
37	0	0	80	0
38	0	0	60	0
39	0	0	40	0
40	0	0	25	0
41	60	0	100	45
42	60	0	100	25

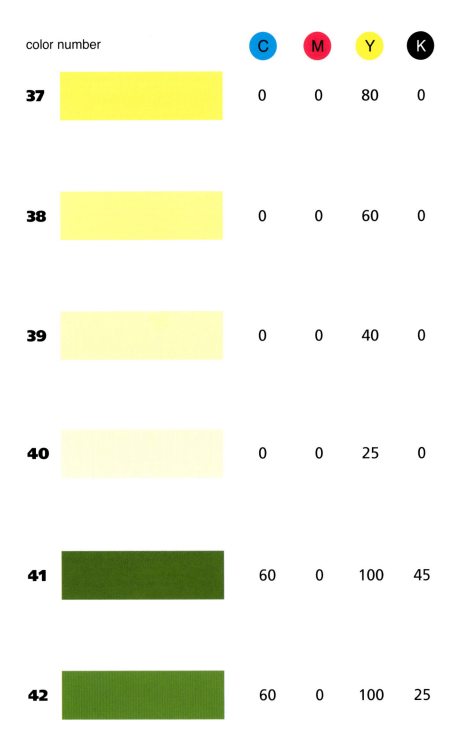

color number		C	M	Y	K
43	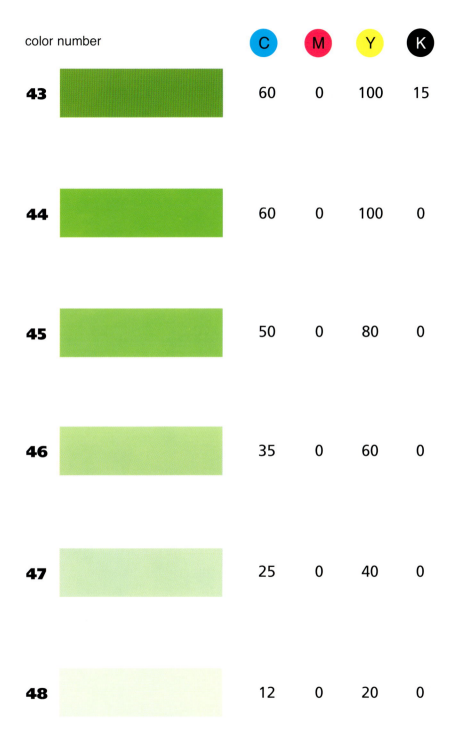	60	0	100	15
44		60	0	100	0
45		50	0	80	0
46		35	0	60	0
47		25	0	40	0
48		12	0	20	0

color number	C	M	Y	K
49	100	0	90	45
50	100	0	90	25
51	100	0	90	15
52	100	0	90	0
53	80	0	75	0
54	60	0	55	0

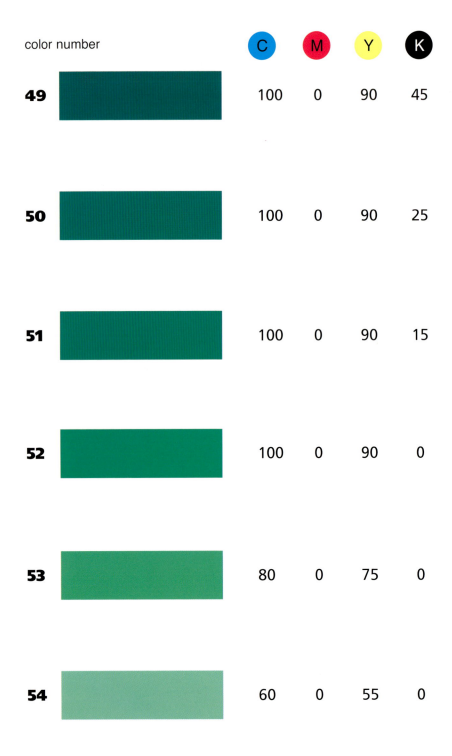

color number		C	M	Y	K
55		45	0	35	0
56		25	0	20	0
57		100	0	40	45
58		100	0	40	25
59		100	0	40	15
60		100	0	40	0

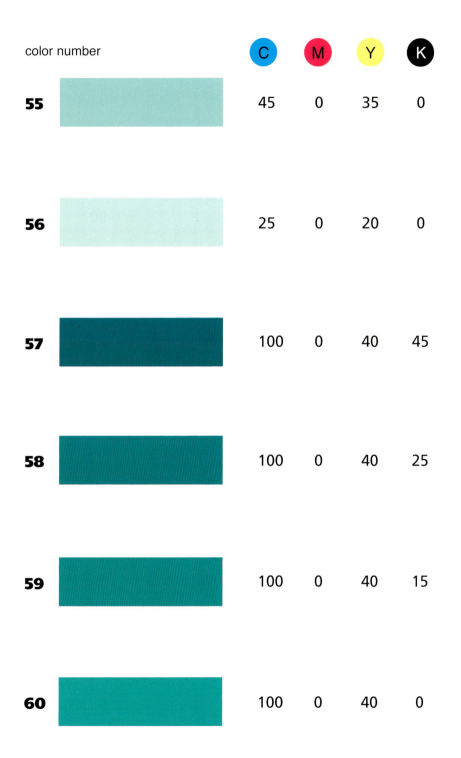

color number	C	M	Y	K
61	80	0	30	0
62	60	0	25	0
63	45	0	20	0
64	25	0	10	0
65	100	60	0	45
66	100	60	0	25

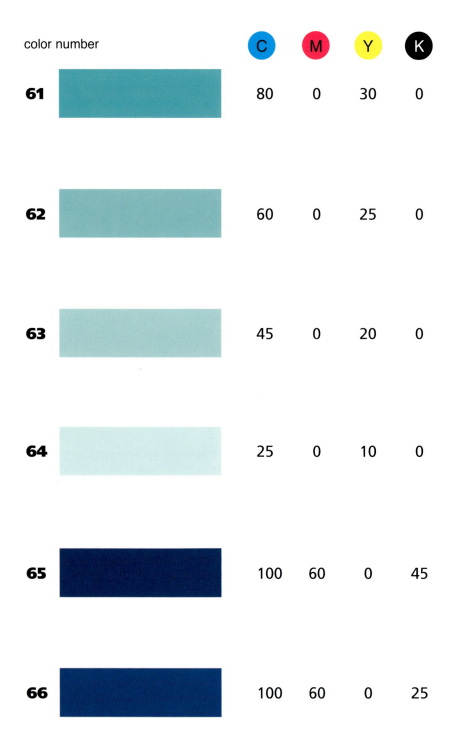

color number		C	M	Y	K
67		100	60	0	15
68		100	60	0	0
69		85	50	0	0
70		65	40	0	0
71		50	25	0	0
72		30	15	0	0

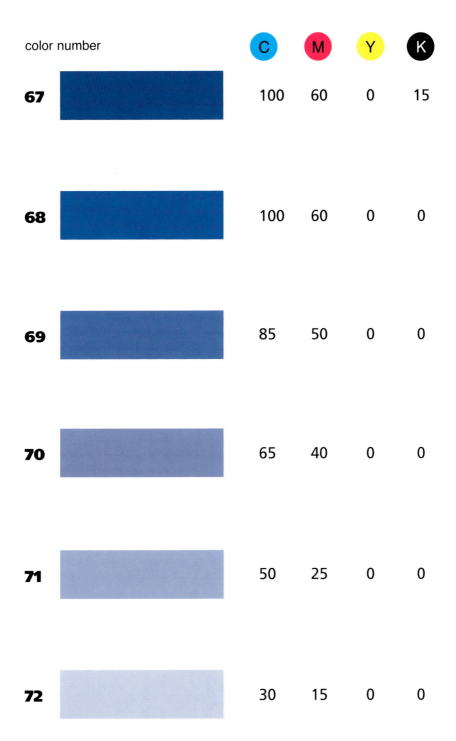

color number	C	M	Y	K
73	100	90	0	45
74	100	90	0	25
75	100	90	0	15
76	100	90	0	0
77	85	80	0	0
78	75	65	0	0

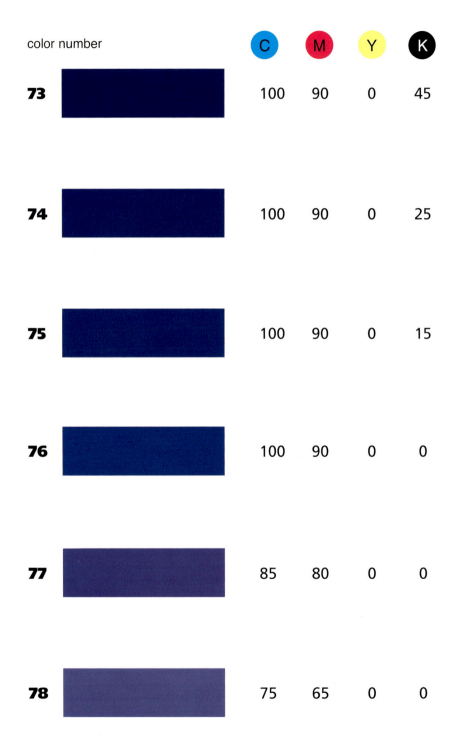

color number		C	M	Y	K
79		60	55	0	0
80		45	40	0	0
81		80	100	0	45
82		80	100	0	25
83		80	100	0	15
84		80	100	0	0

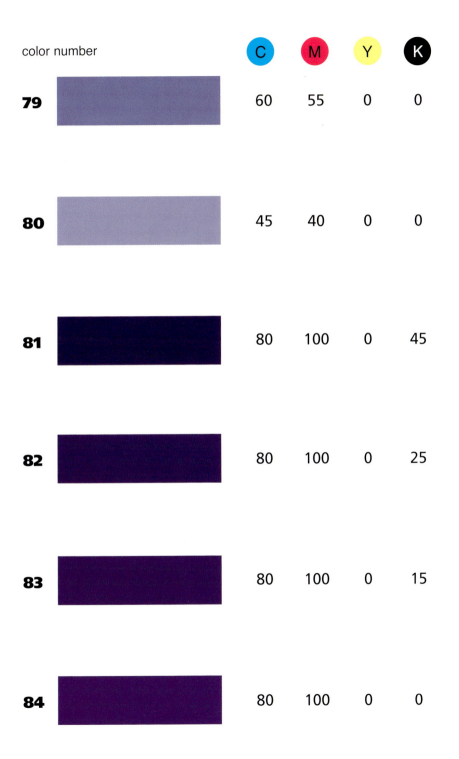

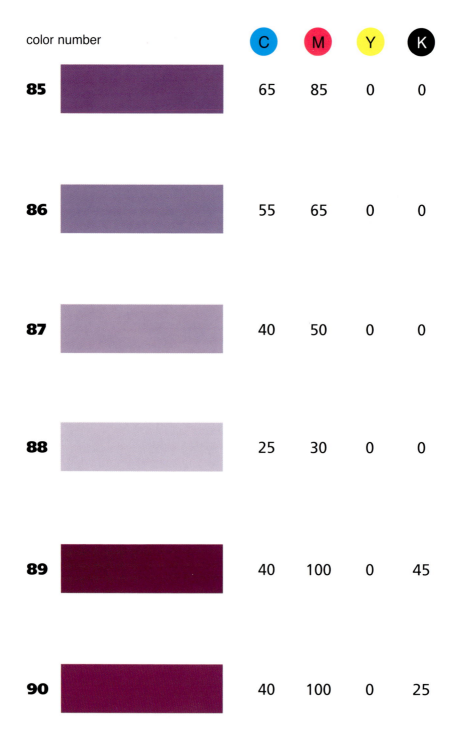

color number	C	M	Y	K
85	65	85	0	0
86	55	65	0	0
87	40	50	0	0
88	25	30	0	0
89	40	100	0	45
90	40	100	0	25

color number		C	M	Y	K
91		40	100	0	15
92		40	100	0	0
93		35	80	0	0
94		25	60	0	0
95		20	40	0	0
96		10	20	0	0

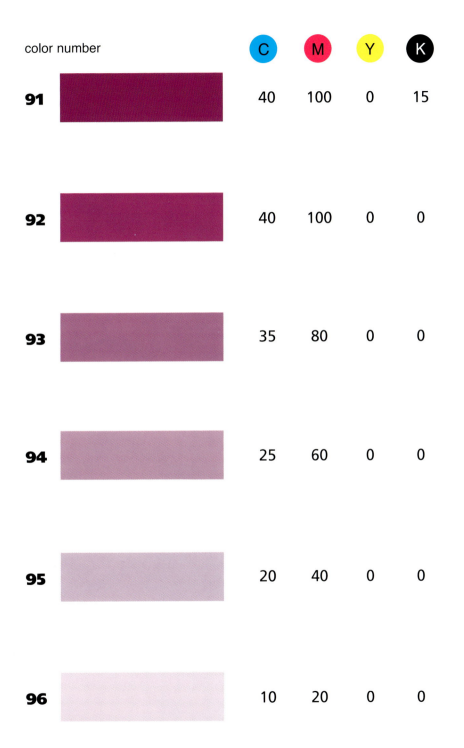

color number	C	M	Y	K
97	0	0	0	10
98	0	0	0	20
99	0	0	0	30
100	0	0	0	35
101	0	0	0	45
102	0	0	0	55

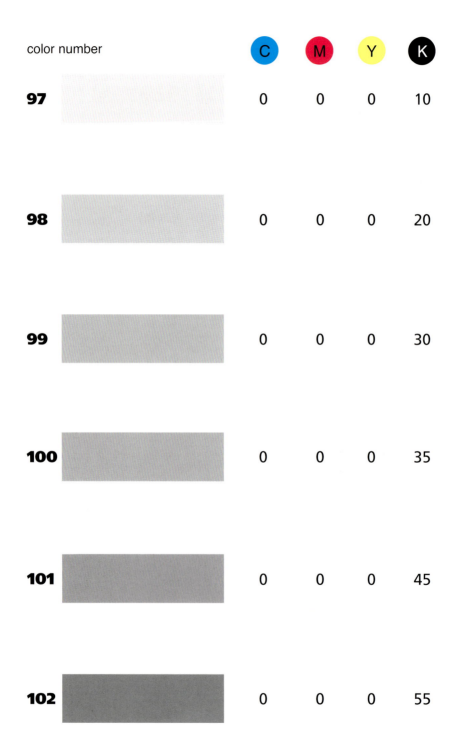

color number	C	M	Y	K
103	0	0	0	65
104	0	0	0	75
105	0	0	0	85
106	0	0	0	100
107	0	0	0	0

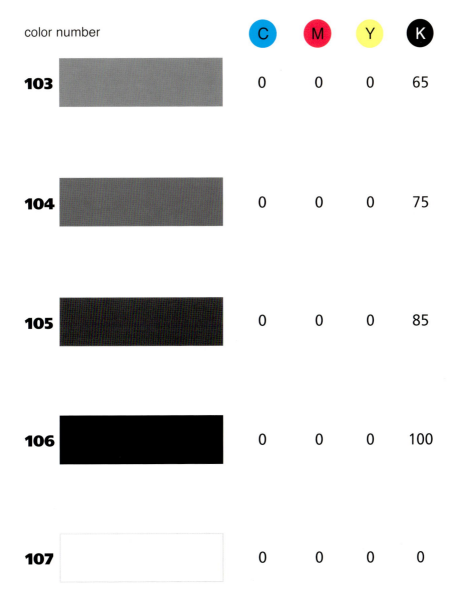

process color chart

color number	C	M	Y	K
1	0	100	100	45
2	0	100	100	25
3	0	100	100	15
4	0	100	100	0
5	0	85	70	0
6	0	65	50	0
7	0	45	30	0
8	0	20	10	0
9	0	90	80	45
10	0	90	80	25
11	0	90	80	15
12	0	90	80	0
13	0	70	65	0
14	0	55	50	0
15	0	40	35	0
16	0	20	20	0
17	0	60	100	45
18	0	60	100	25
19	0	60	100	15
20	0	60	100	0
21	0	50	80	0
22	0	40	60	0
23	0	25	40	0
24	0	15	20	0
25	0	40	100	45
26	0	40	100	25
27	0	40	100	15
28	0	40	100	0

color number	C	M	Y	K
29	0	30	80	0
30	0	25	60	0
31	0	15	40	0
32	0	10	20	0
33	0	0	100	45
34	0	0	100	25
35	0	0	100	15
36	0	0	100	0
37	0	0	80	0
38	0	0	60	0
39	0	0	40	0
40	0	0	25	0
41	60	0	100	45
42	60	0	100	25
43	60	0	100	15
44	60	0	100	0
45	50	0	80	0
46	35	0	60	0
47	25	0	40	0
48	12	0	20	0
49	100	0	90	45
50	100	0	90	25
51	100	0	90	15
52	100	0	90	0
53	80	0	75	0
54	60	0	55	0
55	45	0	35	0
56	25	0	20	0

Color Harmony: Layout

color number	C	M	Y	K
57	100	0	40	45
58	100	0	40	25
59	100	0	40	15
60	100	0	40	0
61	80	0	30	0
62	60	0	25	0
63	45	0	20	0
64	25	0	10	0
65	100	60	0	45
66	100	60	0	25
67	100	60	0	15
68	100	60	0	0
69	85	50	0	0
70	65	40	0	0
71	50	25	0	0
72	30	15	0	0
73	100	90	0	45
74	100	90	0	25
75	100	90	0	15
76	100	90	0	0
77	85	80	0	0
78	75	65	0	0
79	60	55	0	0
80	45	40	0	0
81	80	100	0	45
82	80	100	0	25
83	80	100	0	15
84	80	100	0	0

color number	C	M	Y	K
85	65	85	0	0
86	55	65	0	0
87	40	50	0	0
88	25	30	0	0
89	40	100	0	45
90	40	100	0	25
91	40	100	0	15
92	40	100	0	0
93	35	80	0	0
94	25	60	0	0
95	20	40	0	0
96	10	20	0	0
97	0	0	0	10
98	0	0	0	20
99	0	0	0	30
100	0	0	0	35
101	0	0	0	45
102	0	0	0	55
103	0	0	0	65
104	0	0	0	75
105	0	0	0	85
106	0	0	0	100
107	0	0	0	0

directory of contributors

Catalyst Studios
126 N. Third St., Suite 200
Minneapolis, MN 55401 USA
612.339.0735
www.catalyststudios.com
18

Josh Higgins Design
www.joshhiggins.com
19

Next Century Modern
Andra Långgatan 5
413 03 Gothenburg
Sweden
46.31.7759.333
www.nextcenturymodern.com
21

Origin
20 East Greenway Plaza
3600 Cummins, Suite 150
Houston, TX 77046 USA
713.520.9544
www.origindesign.com
12

Planet Propaganda
605 Willamson
Madison, WI 53703 USA
608.256.0000
www.planetpropaganda.com
17

Ryohei Kojima Design Office
4-19-20 Shirokane-dai Minato-ku
Tokyo 108-0071
Japan
81.3.3447.1474
r-kojima@kk.iij4u.or.jp
16

Strichpunkt
Schoenleinstrasse 8a
70184 Stuttgart
Germany
49.711.620322
www.strichpunkt-design.de
14

Studio Number One
3780 Wilshire Boulevard, Suite 210
Los Angeles, CA 90010 USA
213.383.9299
www.studionumber-one.com
15

tmarks
3429 Fremont Place North #300
Seattle, WA 98103 USA
206.628.6427
www.tmarksdesign.com
13

Werner Design Werks, Inc.
411 1st Ave. N. #206
Minneapolis, MN 55401 USA
612.338.2550
20

about the author

Terry Marks is the principal of the eponymous firm **tmarks** in Seattle, Washington. With a focus on graphic design, the firm has a strong reputation for concept development and writing. In addition to design and marketing, the firm produces film and video.

Marks has been an Executive Board member of the American Institute of Graphic Arts (AIGA), Seattle Chapter. He is also an Executive Board member of LINK, an art outreach program for high school students. Marks was co-chair of *Oodles of Doodles for Your Noodle*, an award-winning activity book for chronically and seriously ill children.

Marks is a contributing writer for *HOW Magazine*, authored portions of a best-selling book for the Augsburg Fortress, and wrote and illustrated an award-winning book, *Mr. Crumbly Dreams A Tiger*. He lectures frequently around the country for universities, design organizations, and conferences, and in his spare time, collaborates on short films.